Cool Restaurants
Shanghai

teNeues

Editor:	Shirley Yuan
Editorial coordination:	Xiwen Cai
Introduction:	Eva Raventós
Photography:	Shenghui Liu. Dish photos: Fan Zhu (p.98, p.76), Changming Chen (p.120), Jereme Leung (p.108) Shenghui Liu (p.30). All others photos by the restaurants.
Copyediting:	Alessandro Orsi
Layout & Pre-press:	Shirley Yuan, Benjamin Cai, Emma Termes Parera
Translations:	Richard Lewis Rees (English), Susanne Engler (German) Michel Ficerai / Lingo Sense (French), Maurizio Siliato (Italian)

Produced by Loft Publications
www.loftpublications.com

Published by teNeues Publishing Group

teNeues Publishing Company
16 West 22nd Street, New York, NY 10010, USA
Tel.: 001-212-627-9090, Fax: 001-212-627-9511

teNeues Book Division
Kaistraße 18, 40221 Düsseldorf, Germany
Tel.: 0049-(0)211-994597-0, Fax: 0049-(0)211-994597-40

teNeues Publishing UK Ltd.
P.O. Box 402, West Byfleet, KT14 7ZF, Great Britain
Tel.: 0044-1932-403509, Fax: 0044-1932-403514

teNeues France S.A.R.L.
4, rue de Valence, 75005 Paris, France
Tel.: 0033-1-55 76 62 05, Fax: 0033-1-55 76 64 19

teNeues Iberica S.L.
Pso. Juan de la Encina 2-48, Urb. Club de Campo
28700 S.S.R.R., Madrid, Spain
Tel./Fax: 0034-91-65 95 876

www.teneues.com

ISBN: 3-8327-9050-0

© 2005 teNeues Verlag GmbH + Co. KG, Kempen

Printed in Italy

Bibliographic information published by Die Deutsche
Bibliothek. Die Deutsche Bibliothek lists this
publication in the Deutsche Nationalbibliografie;
detailed bibliographic data is available in the Internet
at http://dnb.ddb.de.

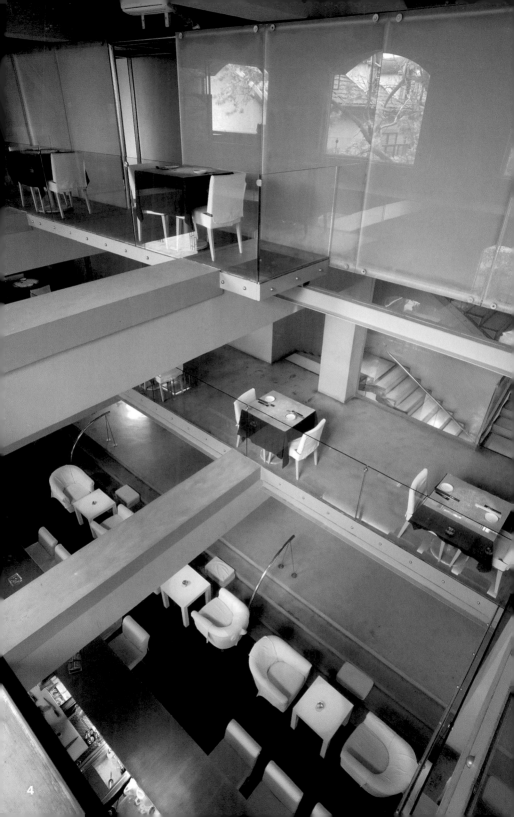

Introduction

Long regarded as the symbol of Western abuse of the East, this bustling city, the most densely populated in the whole of China, is a veritable hotbed of ideas and trends, the country's most avant-garde and chaotic urban potpourri. In Shanghai, colonial buildings rub shoulders with modern high-rise constructions and ancestral traditions coexist with state-of-the-art technological innovations: dissentient characteristics that make up the countenance of a city, a world composed of many worlds, whose contrasts are its greatest charm.

In the nineteen fifties this megalopolis of 14 million inhabitants, for some the New York of the East, initiated a process of meteoric development fostered, among other factors, by the phenomenon of mass immigration in the area. By virtue of its geographical location – the natural outlet to the sea for the provinces of Jiangsu and Zhejiang, where over 120 million people live – and the importance of its port, since time immemorial Shanghai has favored trade relations and evolved differently from the vast majority of other Chinese cities. Today, most of its business is conducted on the banks of the Huangpu, along which the city has grown.

Shanghai's cosmopolitan lifestyle is reflected in the vast range of its culinary attractions, stretching from traditional Chinese dishes and their updated versions to specialties from all over the world. Such abundance is reflected also in the interior design of the city's restaurants: spacious locales, almost invariably characterized by a touch of luxury and grandiloquence, which may be neo-classical or ultra-modern, Zen-influenced or industrial, in which comfort and a select atmosphere provide the ideal setting in which to sample exquisite dishes. Excellent views of the city that customers may enjoy from some of the restaurants – an added attraction this chaotic, colorful city offers – provide the finishing touch to an unforgettable gastronomic experience.

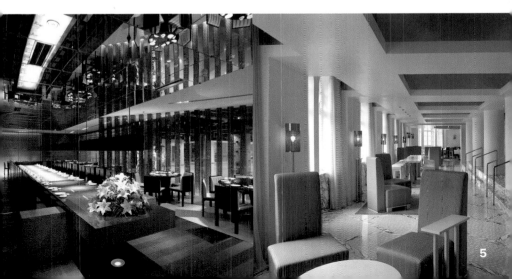

Einleitung

Diese geschäftige Stadt, die bevölkerungsreichste Chinas, die lange Zeit als ein Symbol des Missbrauchs des Ostens durch den Westen betrachtet wurde, ist ein Schmelztiegel für Ideen und Trends, die sie zu der avantgardistischsten und chaotischsten Stadt des Landes machen. In Schanghai stehen Gebäude aus der Kolonialzeit neben modernen Wolkenkratzern, uralte Traditionen bestehen neben den neusten technologischen Innovationen. Diese gegensätzlichen Züge bilden das Antlitz einer Stadt, die aus den Gegensätzen ihren größten Reiz gemacht hat. Eine Welt, die sich aus vielen Welten zusammensetzt.

In dieser Megalopolis mit 14 Millionen Einwohnern, die von manchen als New York des Ostens bezeichnet wird, hat seit den Fünfzigerjahren des 20. Jh. eine rasante Entwicklung stattgefunden, die auch auf eine massive Immigration in dieses Gebiet zurückzuführen ist. Aufgrund der geographischen Situation der Stadt, die für die Provinzen Jiangsu und Zhejiang, wo über 120 Millionen Menschen leben, den natürlichen Zugang zum Meer bildet, und aufgrund des wichtigen Hafens haben sich in Schanghai die Handelsbeziehungen von jeher gut entwickelt, und in einem großen Maße auf andere Weise als in anderen chinesischen Städten. Heute findet der Großteil der Aktivitäten am Ufer des Flusses Huanpu statt, um den herum die Stadt gewachsen ist.

Dieser kosmopolitische Lebensstil spiegelt sich in einem großen gastronomischen Angebot wider. Neben traditionellen chinesischen Gerichten und ihren zeitgenössischen Abwandlungen werden auch kulinarische Spezialitäten aus der ganzen Welt angeboten. Genauso vielseitig ist die Gestaltung der verschiedenen Restaurants, die fast immer etwas luxuriös und großartig gehalten sind. In großen Räumen ist ebenso der neoklassische Stil als auch zeitgenössisches Design zu finden, der Einfluss des Zen-Buddismus oder ein industrieller Charakter. In diesen Restaurants kann man in einer einladenden und gepflegten Atmosphäre köstliche Gerichte genießen. Diese unvergessliche, kulinarische Erfahrung wird in manchen Restaurants noch durch einen wundervollen Blick über die Stadt bereichert, was ebenfalls zum Charme dieser chaotischen und bunten Stadt beiträgt.

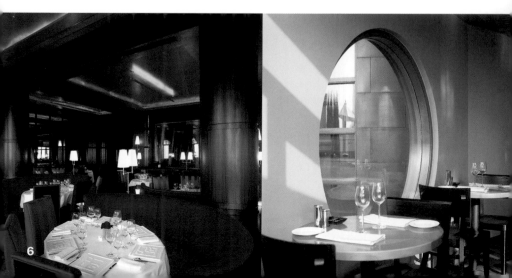

Introduction

Longtemps considérée comme le symbole des abus de 'Occident envers l'Orient, cette ville animée – la plus peuplée de Chine – est un bouillon d'idées et de tendances qui en font la plus avant-gardiste et chaotique du pays. À Shanghai, les constructions coloniales coexistent avec les gratte-ciel modernes, les traditions ancestrales avec les dernières innovations technologiques : des traits en contrepoint formant le visage d'une cité faisant de ses contrastes son principal attrait. Un monde composé d'une multitude d'autres mondes.

Cette mégalopole de 14 millions d'habitants, baptisée par certains la New York de l'Est, a connu à partir des années cinquante un développement accéléré, conséquence également d'une immigration massive. De par sa situation géographique – le débouché naturel sur la mer des provinces de Jiangsu et de Zhejiang, accueillant plus de 120 millions de personnes – et en raison de l'importance de son port, Shanghai a favorisé depuis toujours les relations commerciales et évolué, en grande partie, de manière différente des autres villes chinoises. Aujourd'hui, la majeure partie des activités se déroulent sur les rives du Huanpu, fleuve autour duquel la ville a grandi.

Ce style de vie cosmopolite se reflète dans une offre gastronomique très étendue qui, outre les plats chinois traditionnels et leurs réinventions contemporaines, propose des spécialités culinaires du monde entier. La même abondance de propositions est également manifeste dans le design d'intérieur local qui, presque toujours avec une touche de luxe et de grandiloquence, invente des espaces amples oscillant entre le style néoclassique et le design le plus actuel, l'expression du Zen et le caractère industriel et où le confort et une atmosphère soigneusement choisie forment une entente cordiale avec la possibilité de déguster des plats exquis. Les superbes vues de la ville dont il est possible de jouir depuis quelques uns des restaurants font culminer une expérience culinaire inoubliable et offrent un nouvel attrait à cette cité chaotique et chamarrée.

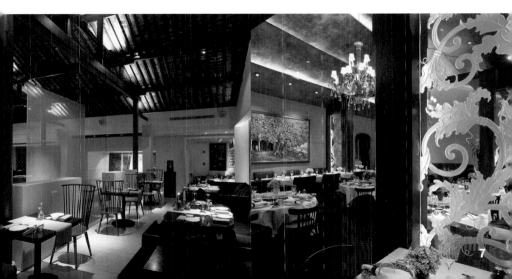

Introducción

Considerada durante mucho tiempo el símbolo del abuso de Occidente sobre Oriente, esta bulliciosa ciudad, la más poblada de China, es un hervidero de ideas y tendencias que la convierten en la más vanguardista y caótica del país; en Shanghai, edificios coloniales conviven con modernos rascacielos, tradiciones ancestrales con las últimas innovaciones tecnológicas; rasgos contrapuestos que conforman el rostro de una ciudad que hace de los contrastes su mayor encanto y que es un mundo que se compone de muchos mundos.

Esta megalópolis de 14 millones de habitantes, denominada por algunos la Nueva York del este, ha experimentado, a partir de los años cincuenta, un desarrollo acelerado, consecuencia también de la inmigración masiva en la zona. Por su situación geográfica –es la salida natural al mar de las provincias de Jiangsu y Zhejiang, donde viven más de 120 millones de personas– y por la importancia de su puerto, Shanghai ha favorecido desde siempre las relaciones comerciales y ha evolucionado, en gran parte, de manera diferente a las demás ciudades chinas. Ahora, la mayoría de las actividades se llevan a cabo a orillas del río Huanpu, alrededor del cual la ciudad ha ido creciendo.

Este estilo de vida cosmopolita se refleja en la amplísima oferta gastronómica de la ciudad que, junto a platos chinos tradicionales y a reelaboraciones contemporáneas, propone especialidades culinarias de todo el mundo. La misma abundancia de propuestas se manifiesta también en el diseño de interiores de los locales, que, casi siempre con un toque de lujo y grandilocuencia, inventa espacios amplios que oscilan entre el estilo neoclásico y el diseño más actual, la expresión zen y el carácter industrial, y donde la comodidad y una atmósfera cuidadosamente elegida no están reñidas con la posibilidad de degustar platos exquisitos. Las excelentes vistas de la ciudad que se pueden disfrutar desde algunos restaurantes culminan una experiencia culinaria inolvidable y proporcionan un atractivo más a esta caótica y colorista ciudad.

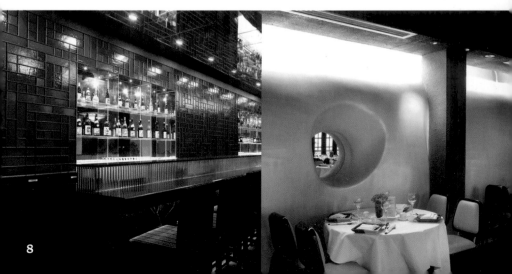

Introduzione

Considerata per molto tempo il simbolo degli abusi dell'Occidente nei confronti dell'Oriente, questa frenetica città, la più popolata di tutta la Cina, è un autentico brulichio di idee e tendenze che fanno di essa la metropoli più caotica e all'avanguardia del paese. A Shanghai convivono edifici coloniali e moderni grattacieli, tradizioni ancestrali e le ultime innovazioni tecnologiche; elementi contrapposti di una città il cui fascino principale risiede proprio nei contrasti. Un mondo che a sua volta si compone di molti altri mondi.

A partire dagli anni cinquanta, questa megalopoli di 14 milioni di abitanti, definita da alcuni la New York dell'est, ha vissuto uno sviluppo accelerato, dovuto anche all'immigrazione di massa che ha interessato la zona. La sua posizione geografica – è lo sbocco naturale al mare delle province di Jiangsu e Zhejiang, dove vivono più di 120 milioni di persone – e l'importanza del suo porto, hanno agevolato da sempre i rapporti commerciali di Shanghai favorendone un'evoluzione in gran parte diversa rispetto a quella delle altre città cinesi. Attualmente, la maggior parte delle attività si svolgono sulle due sponde del fiume Huanpu, attorno al quale la città è via via cresciuta.

Lo stile di vita cosmopolita di Shanghai viene rispecchiato pure dalla sua vasta offerta gastronomica che propone piatti cinesi tradizionali, rielaborazioni contemporanee e specialità culinarie di tutto il mondo. L'abbondanza di proposte caratterizza sia l'ambito culinario che quello dell'arredamento e del design. Gli interni dei locali presentano quasi sempre un tocco di lusso e solennità, ampi spazi che oscillano tra uno stile neoclassico e un design decisamente attuale, tra espressione zen e carattere industriale. Ciò non toglie, però, che in questi ambienti comodi, eleganti e dalle raffinate atmosfere, si possano degustare squisite prelibatezze degne dei palati più fini. Le fantastiche vedute panoramiche della città che si possono godere da alcuni ristoranti coronano perfettamente un'esperienza culinaria indimenticabile e sono al tempo stesso un altro motivo di interesse per visitare questa dinamica e colorata città orientale.

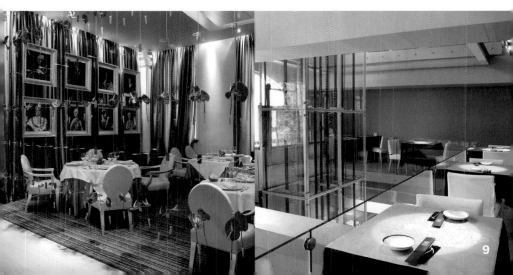

Baci

Design: Roberto Manzini

2a Gao Lan Lu, Fuxing Park I 200020 Shanghai
Phone: +86 21 5383 2328
Subway: Shan Xi Nan Lu or Huang Pi Nan Lu
Opening hours: Every day 11:30 am to 11 pm
Average price: € 18
Cuisine: Italian
Special features: Chic and contemporary dining area, lounge and cocktail bar

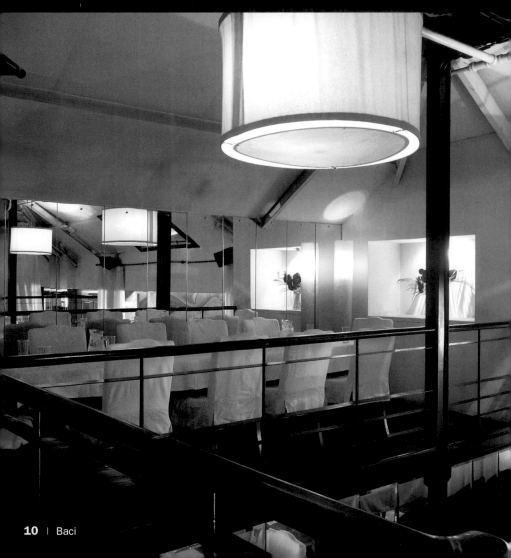

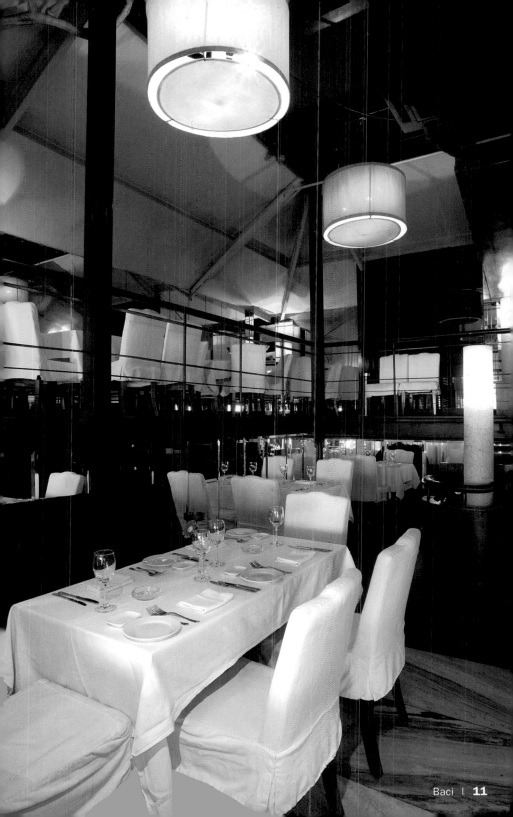

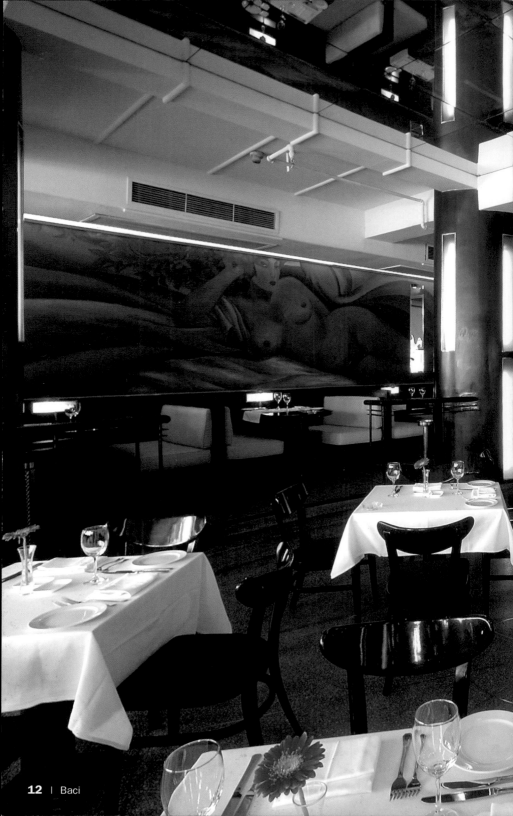

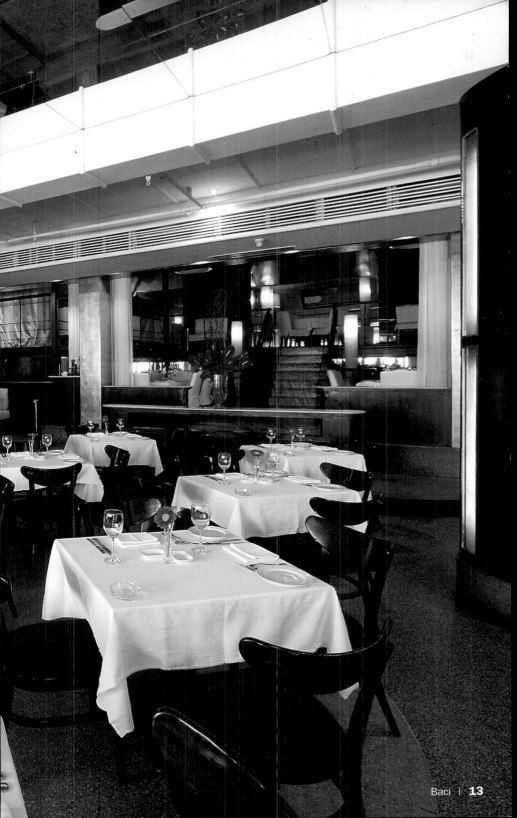

Rice

with Cream of Dublin Bay Prawns

Reis mit Kaisergranatcreme
Riz à la crème d'écrevisse
Arroz con crema de cigalas
Riso con crema di scampi

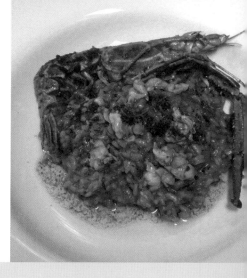

2 1/2 oz rice
5 1/3 oz Dublin Bay prawns
2 1/2 oz peeled tomatoes
2 shallots
1 3/4 oz Chantilly cream
50 ml brandy
100 ml dry white wine
50 ml olive oil
1/6 oz chopped parsley
1 twig thyme
50 ml fish stock
1/6 oz paprika
Salt and black pepper

For the sauce: chop one of the shallots and sauté in a pan previously smeared with butter, add the prawns cut in half (reserve one) and fry for a further 5 minutes. Flambé with the brandy, add 60 ml of the wine and reduce slowly. Then salt to taste, add the black pepper, the parsley and the diced tomatoes. Cover and cook for 10 minutes. Add the Chantilly cream and continue to cook for 2 minutes more. Reserve.
For the rice: finely chop the other shallot and sauté in oil, add the rice and simmer with the remaining wine. Add the fish stock, cook for 10 minutes and add the prawn mixture. Cook for another 2 minutes.
To serve: place in a soup dish, sprinkle with paprika and parsley and decorate with one whole prawn and a twig of thyme.

75 g Reis
160 g Kaisergranat
75 g geschälte Tomaten
2 Schalotten
50 g Chantillycreme
50 ml Kognak
100 ml trockener Weißwein
50 ml Olivenöl
5 g gehackte Petersilie
1 Zweig Thymian
50 ml Fischbrühe
5 g Paprika
Salz und schwarzer Pfeffer

Für die Sauce eine Schalotte stückeln und in einer mit Butter eingeschmierten Schüssel salzen, die in zwei Teile geschnittenen Kaisergranate hinzufügen (einen zur Seite legen) und 5 Minuten anbraten. Mit dem Kognak flambieren, 60 ml Wein hinzugeben und auf kleiner Flamme aufkochen lassen. Anschließend salzen, den schwarzen Pfeffer, Petersilie und die gehackten Tomaten hinzugeben. Abdecken und 10 Minuten kochen lassen. Die Chantillycreme hinzugeben und weitere 2 Minuten kochen lassen. Zur Seite stellen.
Für den Reis: Die andere Schalotte feinhacken und in Öl sautieren, den Reis hinzugeben und mit dem übrigen Wein anbraten. Die Fischbrühe hinzugeben, 10 Minuten kochen lassen und die Masse aus Kaisergranat hinzugeben. Weitere 2 Minuten kochen lassen.
Anrichten: In einen tiefen Teller geben, Paprika und gehackte Petersilie darüber streuen und mit dem ganzen Kaisergranat und einem Thymianzweig dekorieren.

75 g de riz
160 g d'écrevisses
75 g de tomates pelées
2 échalotes
50 g de crème chantilly
50 ml de cognac
100 ml de vin blanc sec
50 ml d'huile d'olive
5 g de persil haché
1 brin de thym
50 ml de bouillon ce poisson
5 g de paprika
Sel et poivre noir

Pour la sauce : détailler une échalote et la faire sauter dans une poêle beurrée. Ajouter les écre-visses coupées en deux (en réserver une) et la sser frire 5 minutes. Flamber avec le cognac, ajouter 6C ml de vin et laisser réduire à feu doux. Par suite, ajouter sel, poivre noir, persil et tomate découpée. Couvrir et laisser cuire 10 minutes. Ajouter la chantilly et faire cuire 2 minutes de plus. Réserver.
Pour le riz : hacher l'autre échalote et la faire sauter dans l huile. Ajouter le riz et le faire revenir avec le reste du vin. Ajouter le bouillon de poissons et cuire 10 minutes pour enfin ajouter la préparation d'écrevisses. Laisser cuire 2 minutes.
Présentation : présenter dans un plat creux. Saupoudrer de paprika et de persil haché et décorer de l'écrevisse entière et d'un brin de thym.

75 g de arroz
160 g de cigalas
75 g de tomates pelados
2 chalotes
50 g de crema chantillí
50 ml de coñac
100 ml de vino blanco seco
50 ml de aceite de oliva
5 g de perejil picado
1 rama de tomillo
50 ml de caldo de pescado
5 g de pimentón
sal y pimienta negra

Para la salsa, cortar un chalote en trozos y saltearlo en una sartén untada con mantequilla, añadir las cigalas cortadas por la mitad (reservar una) y freír durante 5 minutos. Flambear con el coñac, añadir 60 ml de vino y dejar reducir a fuego lento. Luego salar, añadir la pimienta negra, el perejil y el tomate troceado. Tapar y dejar cocer durante 10 minutos. Agregar la crema chantillí y cocer durante 2 minutos más. Reservar.
Para el arroz, picar el otro chalote y saltearlo en en aceite, agregar el arroz y sofreírlo con el vino restante. Añadir el caldo de pescado, cocer durante 10 minutos y agregar el preparado de cigalas. Dejar cocer 2 minutos.
Emplatado: presentar en un plato hondo, espolvorear con pimentón y perejil picado y decorar con una cigala entera y una rama de tomillo.

75 g di riso
160 g di scampi
75 g di pomodori pelati
2 scalogni
50 g di crema chartilly
50 ml de cognac
100 ml di vino bianco secco
50 ml di olio d'oliva
5 g di prezzemolo tritato
1 rametto di timo
50 ml di brodo di pesce
5 g di paprica
sale e pepe nero

Per preparare la salsa, tagliare a pezzi uno scalogno e saltarlo in una padella imburrata, quindi aggiungervi gli scampi tagliati a metà (metterne da parte uno) e friggere per 5 minuti. Flambare con il cognac aggiungere 60 ml di vino e lasciare ridurre a fuoco lento. Dopodiché salare, aggiungere il pepe nero, il prezzemolo e il pomodoro tagliato a pezzi. Coprire e far cuocere per 10 minuti. Unire la crema chantilly e cuocere per altri 2 minuti. Mettere da parte.
Per il riso, tritare l'altro scalogno e saltarlo nell'olio, aggiungere il riso e soffriggerlo con il vino restante. Aggiungere il brodo di pesce, cuocere per 10 minuti e unire il preparato di scampi. Far cuocere per 2 minuti.
Presentazione: disporre in un piatto fondo, spolverizzare con paprica e prezzemolo tritato e decorare con uno scampo intero e un rametto di timo.

Cigar Jazz Wine

222 Yanan Dong Lu, 50th floor, Bund Center | 200002 Shanghai
Phone: +86 21 6339 1777
www.bundcenter.com
Subway: He Nan Zhong Lu
Opening hours: Every day 11:30 am to 2:30 pm, and 6 pm to 10:30 pm
Average price: € 7–28
Cuisine: Continental
Special features: Complete wine menu, live music

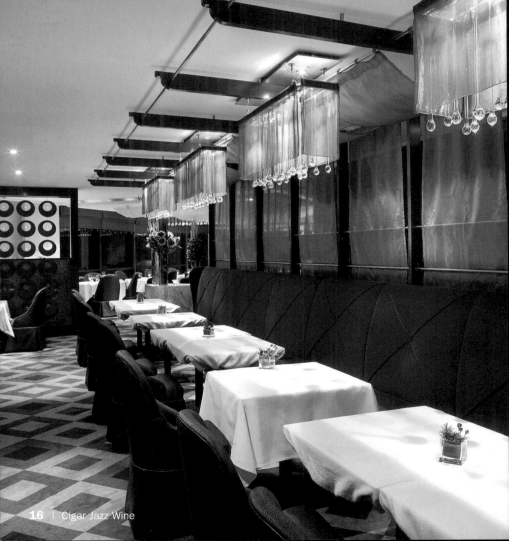

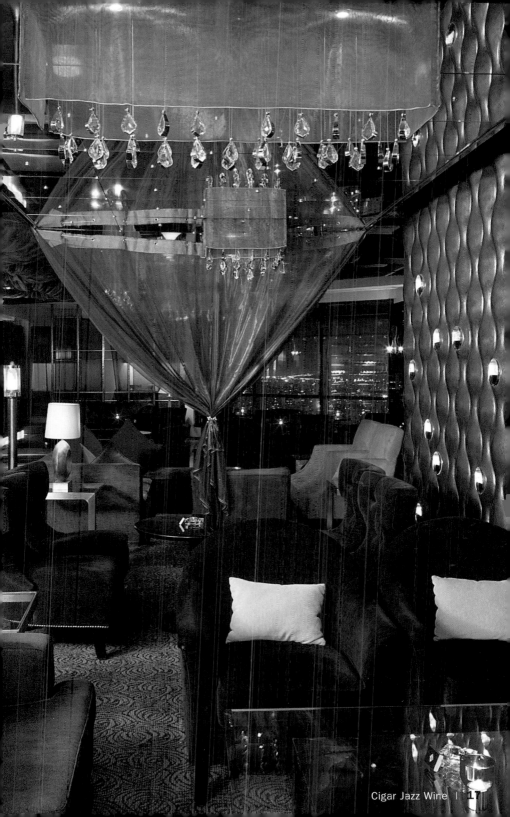

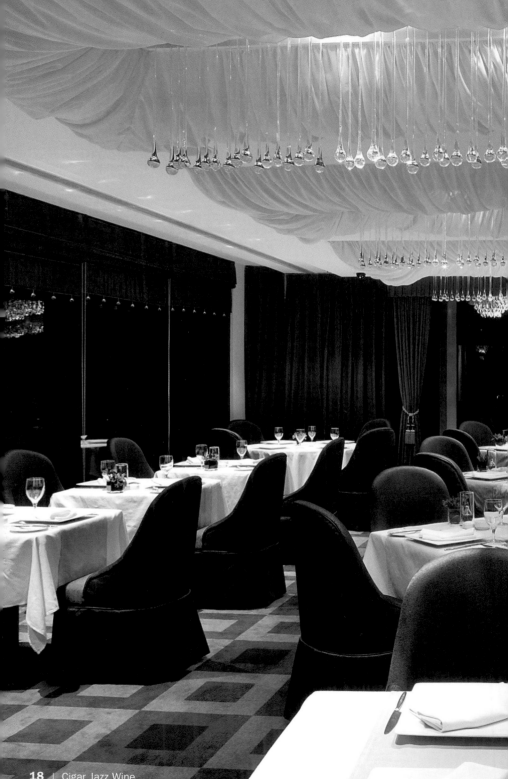

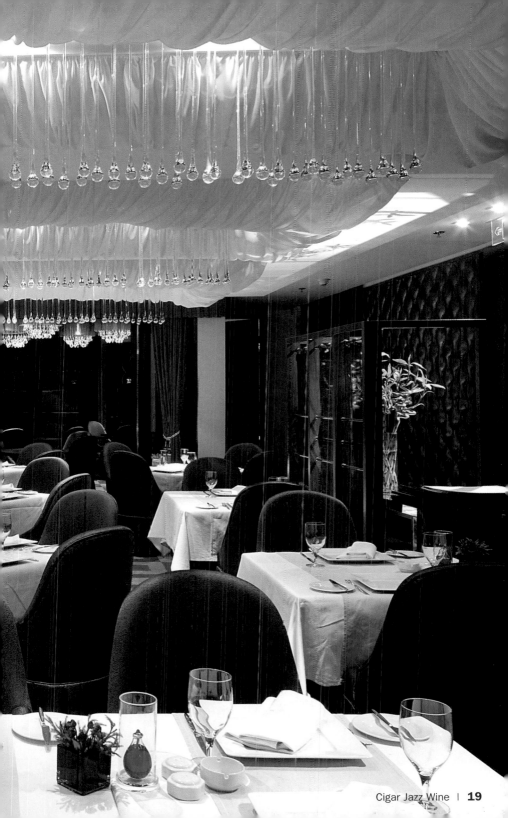

Club Jin Mao

Design: Bilkey Llinas Consulting I Chef: Wei ShenMao

88 Century Boulevard, Jin Mao Tower, 86th floor, Pudong I 200121 Shanghai
Phone: +86 21 5049 1234
www.shanghai.grand.hyatt.com
Subway: Lu Zia Zui
Opening hours: 11:30 am to 2:30 pm, and 5:30 pm to 10 pm
Average price: € 37
Cuisine: Shanghainese
Special features: Chinese art deco with extensive views of the city

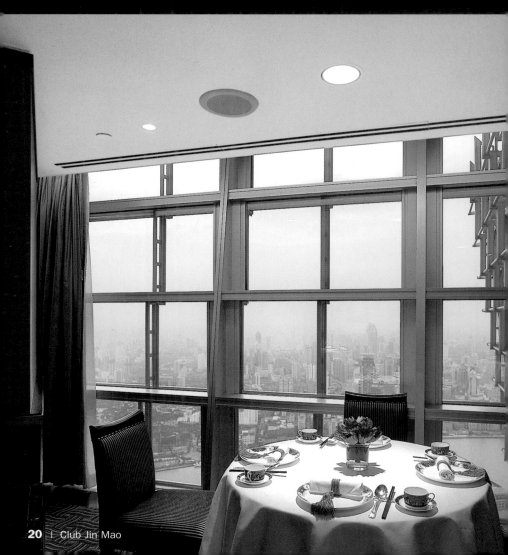

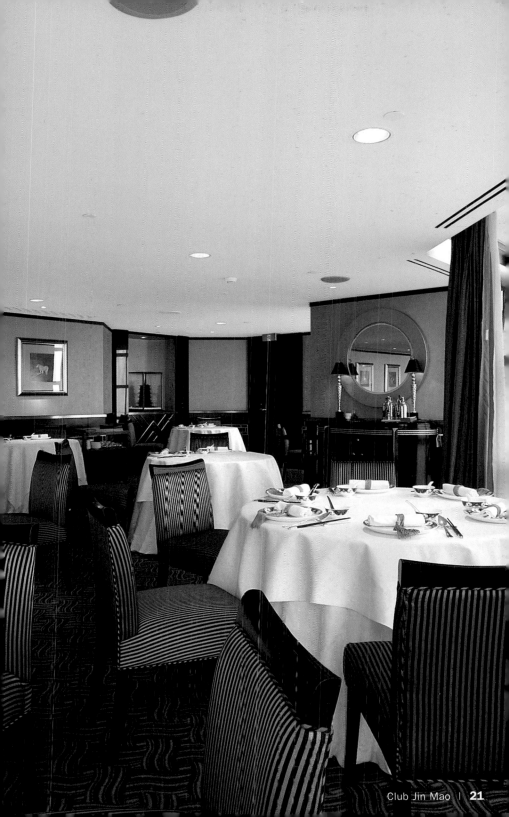

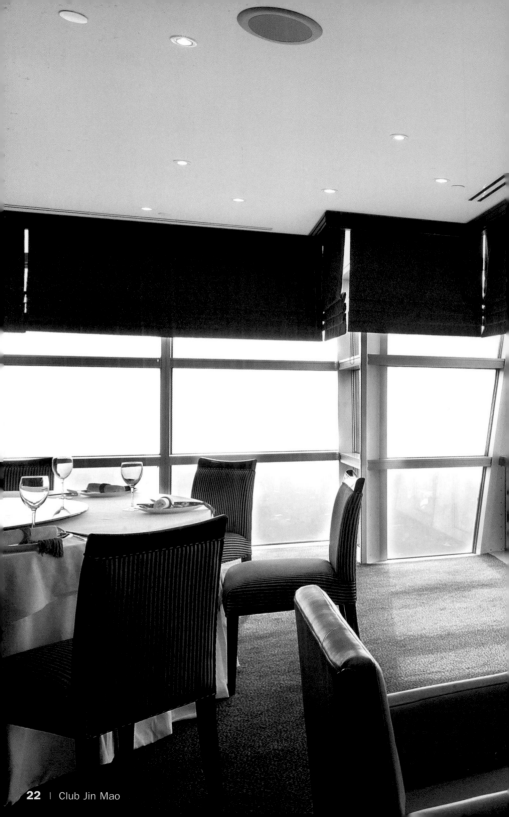

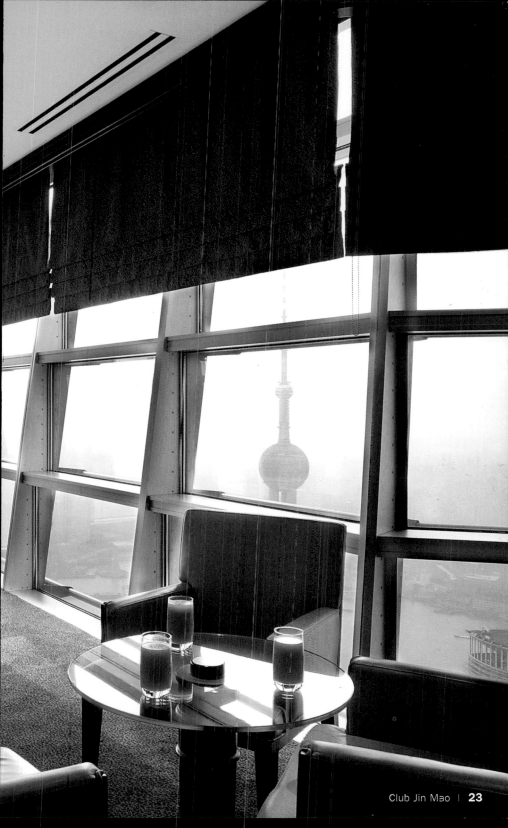

Abalones
with Apple

Seeohr mit Apfel
Ormeaux aux pommes
Orejas de mar con manzana
Orecchie di mare alle mele

5 oz abalones
3 oz broccoli
1 Chinese mushroom
4 apples
1/6 oz honey
1/3 oz sugar
15 ml soy sauce
25 ml white wine
125 ml water
Powdered ginger
Gelatin
Salt

Make a compote by boiling three diced apples, the honey, the sugar and the wine together to a thick consistency. Beat in the blender and reserve. Boil the remaining apple whole, skin included, cut into slices and reserve. Steam the broccoli and the Chinese mushroom and allow to cool. Pour the water and soy sauce into a casserole, add the abalones and cook until the sauce is reduced. Sprinkle with the ginger and remove from the flame.
To serve: in the middle of a plate make a mound of compote and cover it with the apple slices with the mushroom on top. Crown with the broccoli and place the abalones around the mound. 'Paint' with gelatin before serving.

150 g Seeohr
85 g Brokkoli
1 chinesischer Pilz
4 Äpfel
5 g Honig
10 g Zucker
15 ml Sojasauce
25 ml Weißwein
125 ml Wasser
Ingwerpulver
Gelatine
Salz

Zur Herstellung eines Kompotts drei in Würfel geschnittene Äpfel, Honig, Zucker und Weißwein kochen, bis eine dickflüssige Masse entsteht. Durchschlagen und zur Seite stellen. Den letzten Apfel ganz mit der Haut kochen, in Streifen schneiden und beiseite stellen. Den Brokkoli und den chinesischen Pilz dampfkochen, vom Feuer nehmen und abkühlen lassen. Wasser, die Sojasauce und die Seeohren in einen Topf geben und aufkochen lassen, bis die Sauce reduziert ist. Ingwerpulver darüber streuen und vom Herd nehmen.
Anrichten: In der Mitte des Tellers das Apfelkompott aufhäufen, mit den gekochten Apfelscheiben bedecken und in die Mitte den chinesischen Pilz geben. Mit Brokkoli krönen und darum herum die Seeohren anordnen. Vor dem Servieren mit Gelatine überziehen.

150 g d'ormeaux
85 g de brocoli
1 champignon chinois
4 pommes
5 g de miel
10 g de sucre
15 ml de sauce soja
25 ml de vin blanc
125 ml d'eau
Gingembre en poudre
Gélatine
sel

Préparer une compote en faisant bouillir trois pommes coupées en dés, le miel, le sucre et le vin blanc pour obtenir une masse épaisse. Passer au mixer et réserver. Faire bouillir la pomme restante entière (avec la peau), l'émincer et la réserver. Cuire le brocoli et le champignon chinois à la vapeur. Retirer et laisser refroidir. Dans une casserole d'eau, verser la sauce soja et y plonger les ormeaux. Cuire pour faire réduire la sauce. Saupoudrer du gingembre et retirer.
Présentation : au centre du plat, disposer la compote de pommes en monticule. La couvrir des lamelles de pomme bouillie et, au centre, décorer du champignon chinois. Couronner du brocoli et disposer les ormeaux autour. Avant de servir, badigeonner de gélatine.

150 g de orejas de mar
85 g de brócoli
1 seta china
4 manzanas
5 g de miel
10 g de azúcar
15 ml de salsa de soja
25 ml de vino blanco
125 ml de agua
jengibre en polvo
gelatina
sal

Hacer una compota hirviendo tres manzanas cortadas en dados, la miel, el azúcar y el vino blanco hasta conseguir una masa espesa. Pasar por la batidora y reservar. Hervir la manzana restante entera con piel, laminar y reservar. Cocer el brócoli y la seta china al vapor, retirar y dejar enfriar. En una cazuela, echar el agua, la salsa de soja y las orejas de mar. Cocinar hasta que se reduzca la salsa. Espolvorear con el jengibre y retirar.
Emplatado: En el centro de un plato, colocar la compota de manzana en forma de montículo, cubrir con las láminas de la manzana hervida y, en el centro, adornar con la seta china. Coronar con el brócoli y disponer alrededor las orejas de mar. Antes de servir, pintar con gelatina.

150 g di orecchie di mare
85 g di broccoli
1 fungo cinese
4 mele
5 g di miele
10 g di zucchero
15 ml di salsa di soia
25 ml di vino bianco
125 ml d'acqua
zenzero in polvere
gelatina
sale

Preparare una composta facendo bollire tre mele tagliate a dadi, il miele, lo zucchero e il vino bianco, fino ad ottenere una pasta spessa. Passare il tutto nel frullino e mettere da parte. Bollire la mela restante intera e senza sbucciarla, quindi tagliarla a lamine e mettere da parte. Cuocere i broccoli e il fungo cinese al vapore, ritirare dal fuoco e far raffreddare. In una casseruola, versare l'acqua, la salsa di soia e le orecchie di mare. Cuocere fino a far ridurre la salsa. Cospargere di zenzero e ritirare dal fuoco.
Presentazione: al centro di un piatto, sistemare la composta di mela a forma di monticello, coprire con le lamine di mela bollita e, al centro, decorare con il fungo cinese. Coronare con i broccoli e attorno disporre le orecchie di mare. Prima di servire, spennellare con la gelatina.

Crystal Jade

Unit 12A & 12B, 1/F, House 6–7, Lane 123, Xingye Lu, South Block, Xintiandi Plaza I
200021 Shanghai
Phone: +86 21 6385 8752
www.xintiandi.com
Subway: Huang Pi Nan Lu
Opening hours: Every day 11 am to 11 pm
Average price: € 8, Dinner € 11
Cuisine: Cantonese
Special features: Innovative lighting, that creates a wide range of ambiences

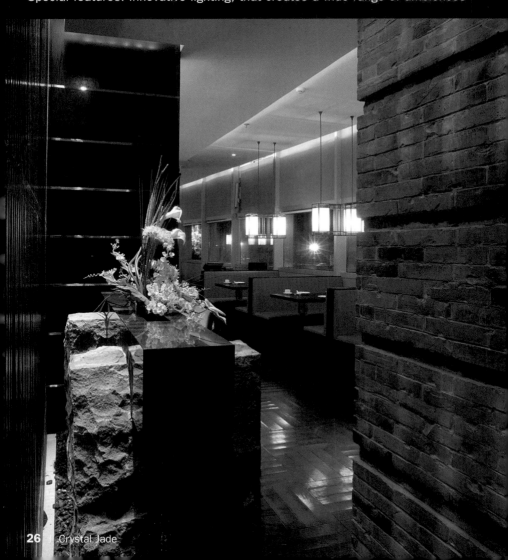

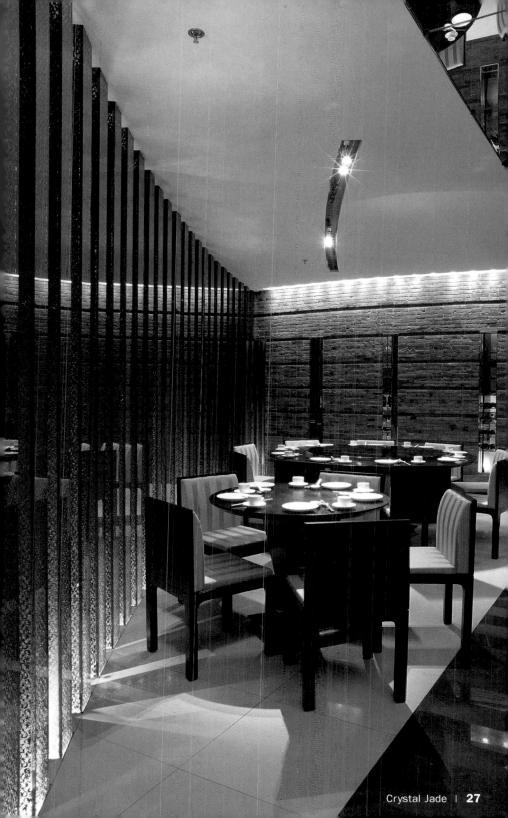

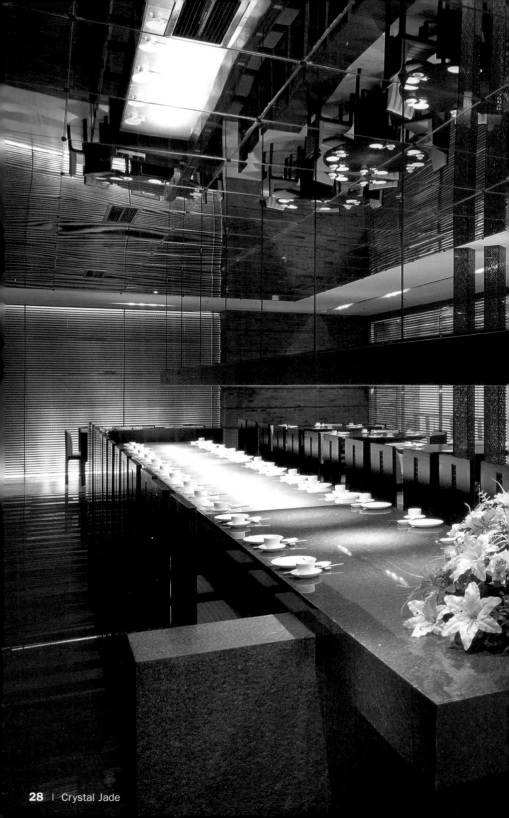

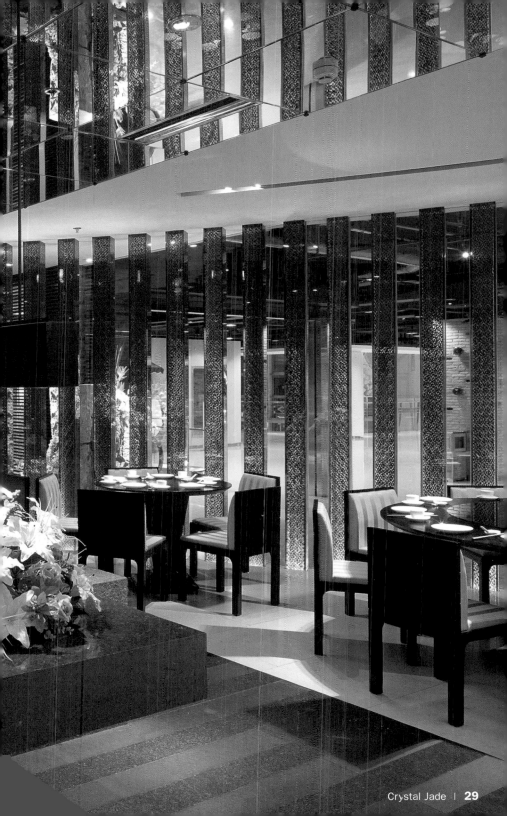

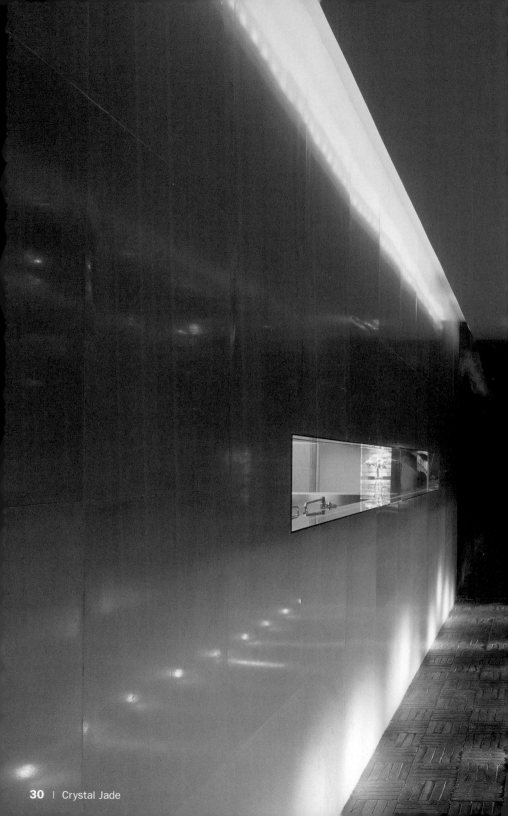

Herbal Legend

Design: Geogle Yao I Chef: Yi Tang

House 1, Lane 123, Xingye Lu, South Block, Xintiandi Plaza I 200021 Shanghai
Phone: +86 21 6386 6817-18
www.xintiandi.com
Subway: Huang Pi Nan Lu
Opening hours: Every day 11 am to 1 pm
Average price: € 14–18
Cuisine: Traditional Herbal Gourmet
Special features: Artistic interiors with calligraphy display

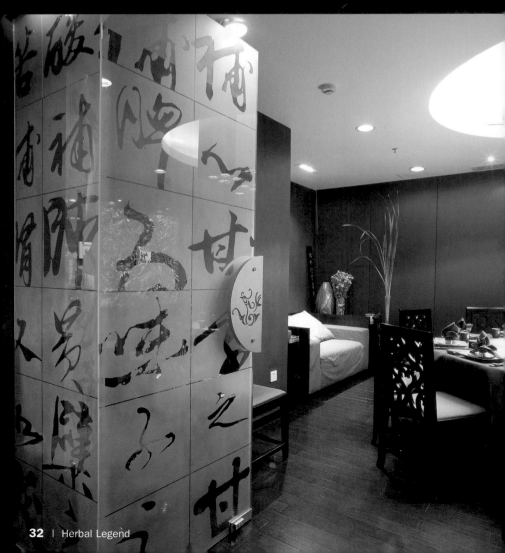

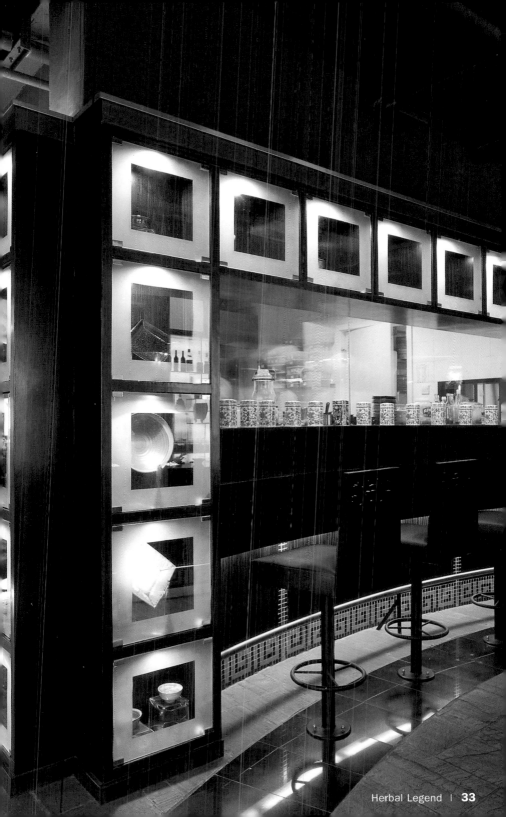

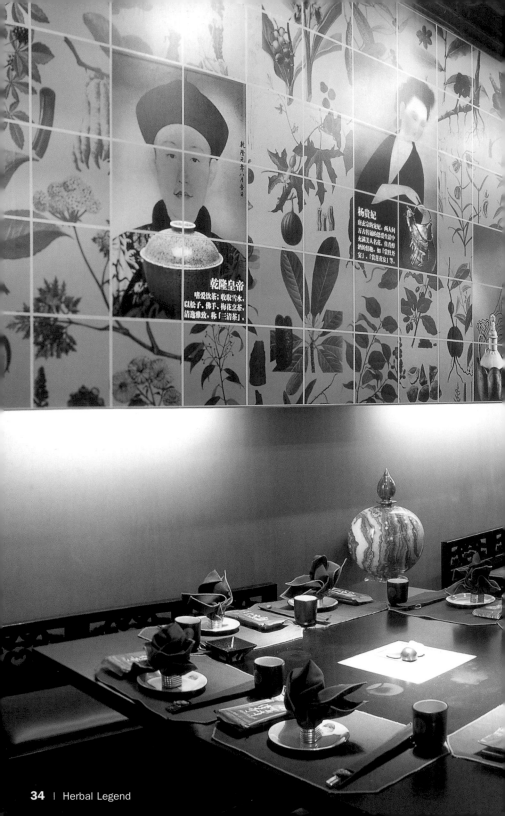

乾隆皇帝
嗜爱饮茶；收取雪水，
以松子、佛手、梅花烹茶，
清逸雅致，称「三清茶」。

杨贵妃
唐玄宗的爱妃，两人间
万古传颂的恩爱生活中
充满美人名花，佳肴醇
酒的情趣，如「贵妃牡丹
宴」、「贵妃花宴」等。

Duck with Aweto

Ente mit Aweto
Canard à l'aweto
Pato con aweto
Anatra con aweto

6 1/2 oz duck pieces
1 spare rib
1/8 oz sliced ginseng
1 pinch ginger
2 awetos
6 Chinese wolfberries (Lycium chinense)

Boil the duck and the spare rib, then rinse and reserve. Pour the water in which the duck was boiled into another saucepan, add the ginseng, the ginger, the awetos and the wolfberries. Steam for 30 minutes, then add the rib and the duck pieces and continue to cook for a further 2 hours and 30 minutes.
Serve hot in a bowl.

180 g gestückelte Ente
1 Schweinerippchen
3 g in Scheiben geschnittener Ginseng
1 Prise Ingwer
2 Aweto
6 Körner vom Chinesischen Bocksdorn [Lycium chinense]

Die Ente und das Schweinerippchen kochen, waschen und zur Seite stellen. Das Wasser, in dem die Ente gekocht wurde, in einen anderen Topf gießen. Den Ginseng, Ingwer, Aweto und die Körner des Chinesischen Bockshorns hinzufügen. 30 Minuten im Dampf kochen, das Schweinerippchen und die Entenstücke hinzugeben, dann weitere zweieinhalb Stunden kochen.
Anrichten: Heiß in einer Suppenschüssel servieren.

180 g de canard en pièces
1 côte de porc
3 g de ginseng laminé
1 prise de gingembre
2 aweto
6 baies de lyciet chinois

Cuire le canard et la côte de porc, puis les laver et les réserver. Verser dans une autre casserole de l'eau pour faire bouillir le canard. Ajouter le ginseng, le gingembre, l'aweto et les baies de lyciet chinois. Cuire 30 minutes à la vapeur puis ajouter la côte et les morceaux de canard et poursuivre la cuisson pendant 2 heures et demie.
Présentation : servir chaud dans un plat creux.

180 g de pato troceado
1 costilla de cerdo
3 g de ginseng laminado
1 pizca de jengibre
2 aweto
6 granos de cambrón chino [Lycium chinense]

Cocer el pato y la costilla de cerdo, luego lavarlos y reservar. Verter en otra cazuela el agua donde se ha hervido el pato. Añadir el ginseng, el jengibre, el aweto y los granos de cambrón chino. Cocer al vapor durante 30 minutos, luego agregar la costilla y los trozos de pato y seguir cociendo durante 2 horas y media.
Emplatado: Servir caliente en un un cuenco.

180 g di anatra a pezzi
1 costoletta di maiale
3 g di ginseng a lamine
1 pizzico di zenzero
2 aweto
6 chicchi di wolfberry cinese [Lycium chinense]

Cuocere l'anatra e la costoletta di maiale, quindi lavarle e metterle da parte. In un altro tegame versare l'accua di cottura dell'anatra. Aggiungere il ginseng, lo zenzero, l'aweto e i chicchi di wolfberry cinese. Cuocere al vapore per 30 minuti, dopo unire la costoletta e i pezzi di anatra e continuare la cottura per 2 ore e mezzo.
Presentazione: servire caldo in una scodella.

Hot Pot Shanghai

Chef: Zhiqiang Deng

2378 Jianhe Lu | 200336 Shanghai
Phone: +86 21 6237 6218
Opening hours: Every day 10:30 am to 10:30 pm
Average price: € 56
Cuisine: New Wave hot pot
Special features: Reminiscent Shanghai art deco furniture

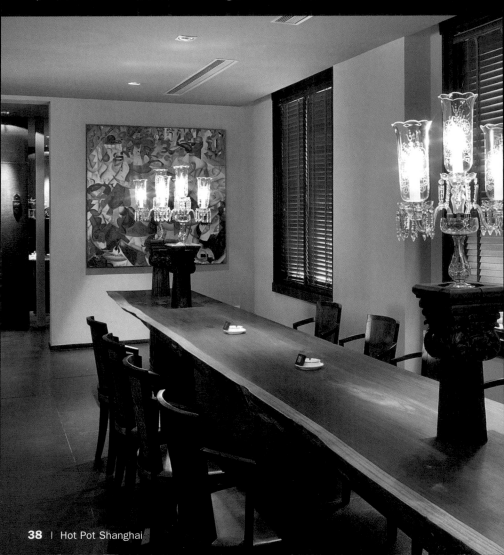

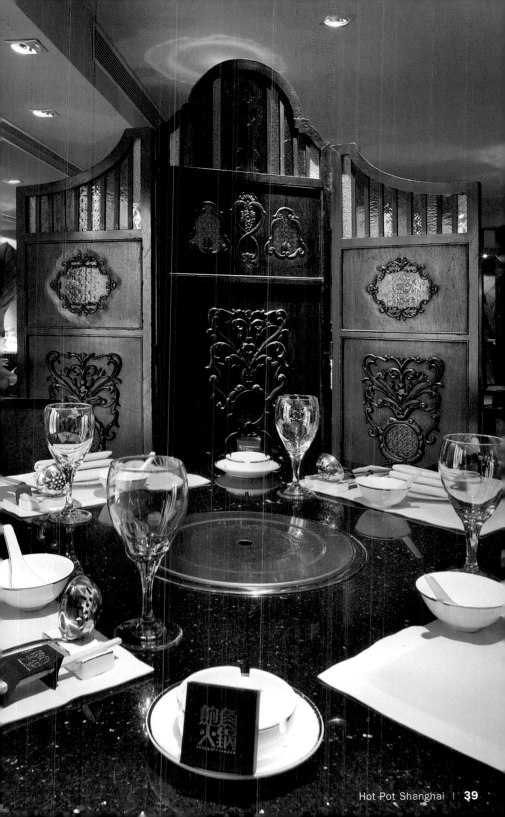

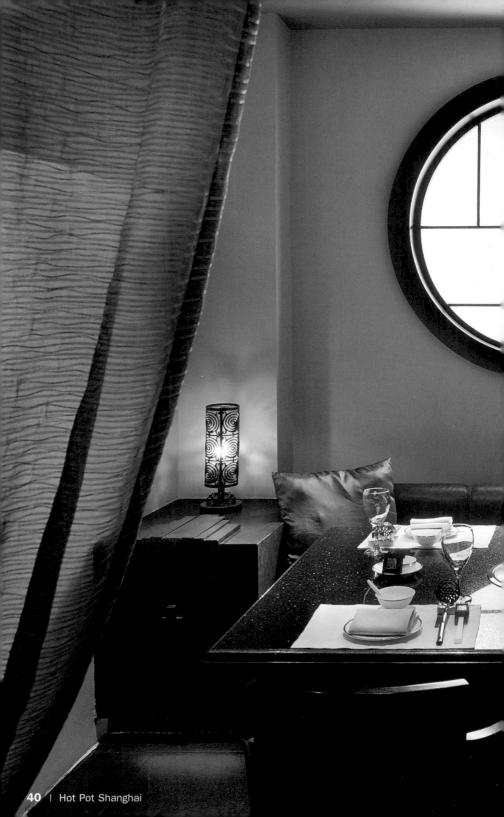

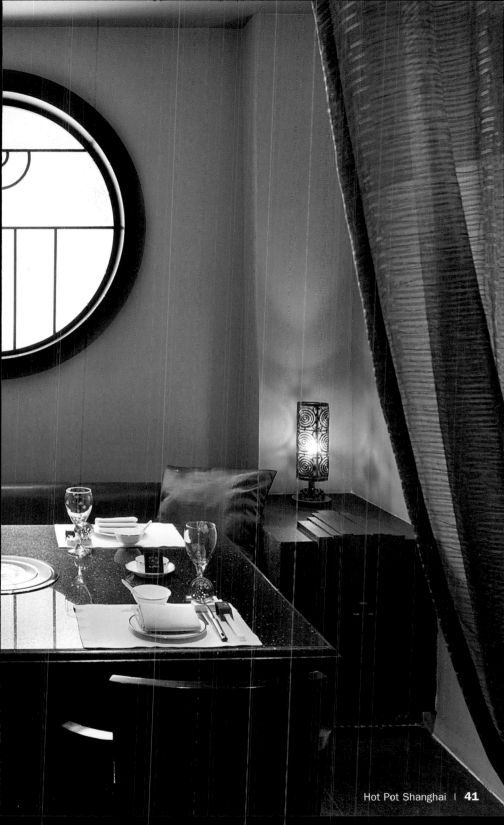

Jean Georges

Design: Michael Graves I Chef: Jean-Georges Vongerichten

3 Zhong Shan Dong Yi Lu, No. 3 The Bund, 4th Floor I 200002 Shanghai
Phone: +86 21 6321 7773
www.threeonthebund.com
Subway: He Nan Zhong Lu
Opening hours: Every day 11:30 am to 2:30 pm, and 18:00 pm to 10 pm;
bar 11:30 am to 1 am
Average price: € 75
Cuisine: Innovative French

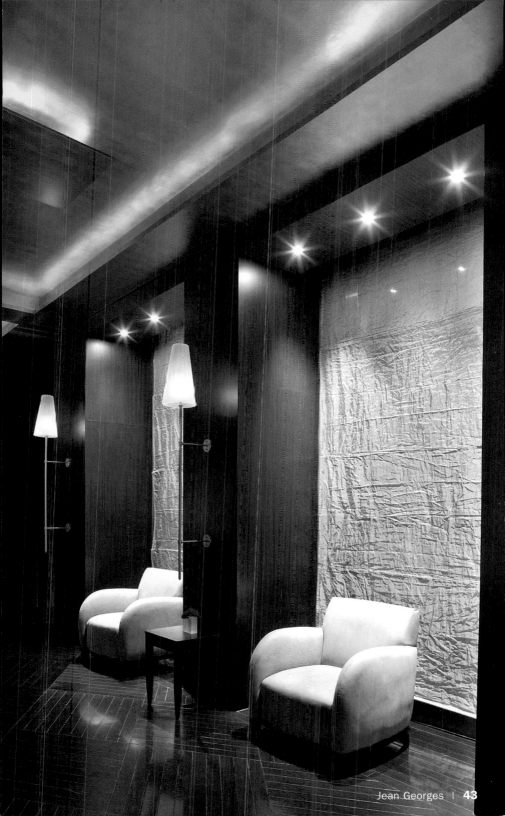

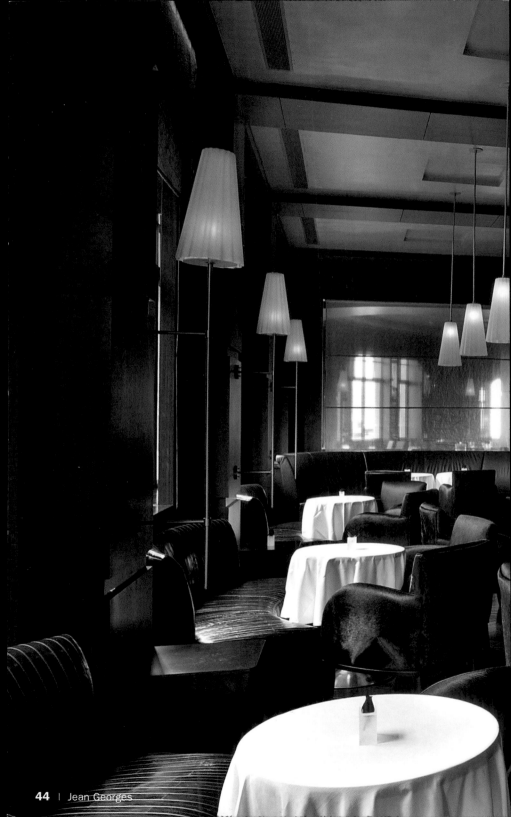

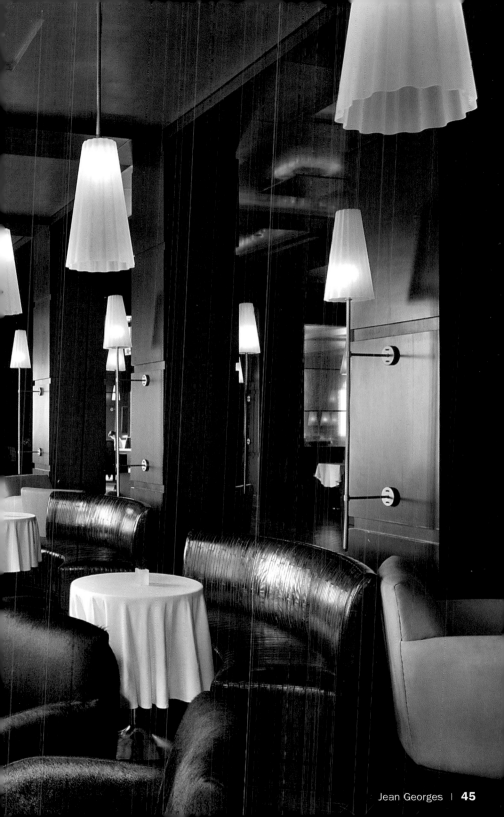

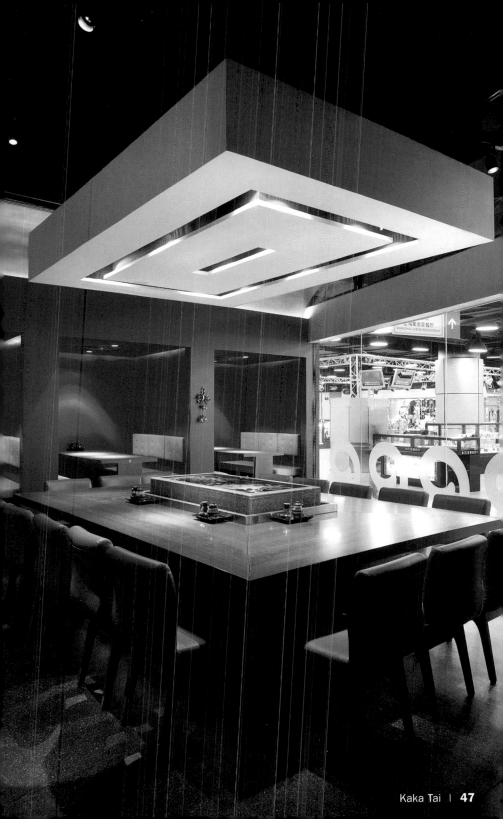

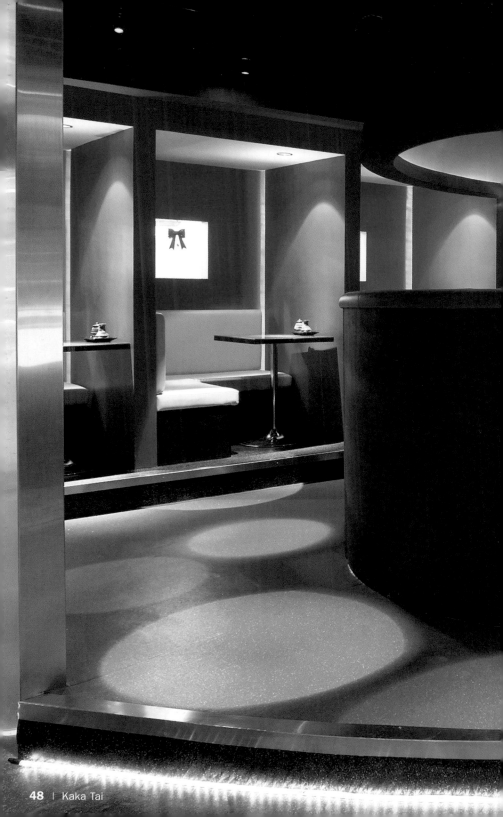

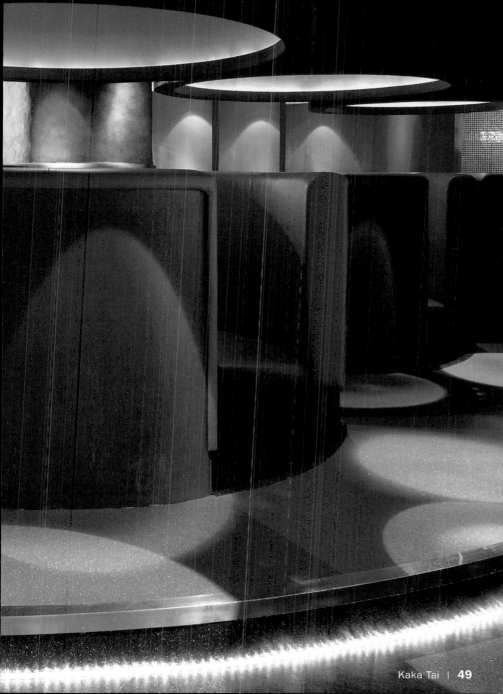

Sushi

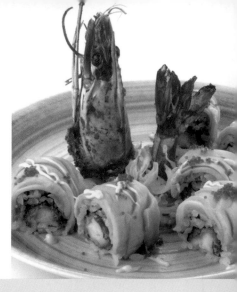

1 king prawn
1/2 avocado
1 oz thin seaweed strips
3 1/2 oz rice
1/3 oz breadcrumbs
Salt

Boil the rice for 15 minutes in salted water, remove from the flame and leave to stand for 10 minutes. Rinse and allow to cool. Roll the prawn in the breadcrumbs and fry. Mash the avocado. Place the seaweed strips on a wooden board, mix the rice and the avocado together and spread the mixture on the seaweed. Cut off the prawn's head and tail and place the remainde on the layer of rice. Roll the seaweed to form a compact cylinder with the prawn in the center Cut the cylinder into 2-cm portions.
Serve on a plate and decorate with the head and tail.

1 Garnele
1/2 Avocado
30 g Meeresalgen in Streifen
100 g Reis
10 g Paniermehl
Salz

Den Reis in einem Topf mit Salzwasser 15 Minuten kochen, dann vom Feuer nehmen und 10 Minuten ruhen lassen. Abtropfen und abkühlen lassen. Die Garnele im Paniermehl panieren und frittieren. Die Avocado klein hacken. Die Algen-streifen auf ein Holzbrett legen, den Reis mit der gehackten Avocado mischen und eine Schicht der Masse auf die Algen legen. Den Kopf und den Schwanz der Garnele entfernen und sie über die Reisschicht legen. Die Algen um sich selbst rollen, so dass die Garnele in der Mitte bleibt und ein kompakter Zylinder entsteht. Der Zylinder in 2 cm lange Portionen schneiden.
Anrichten: Auf einem flachen Teller servieren und mit dem Kopf und dem Schwanz der Garnele dekorieren.

1 écrevisse
1/2 avocat
30 g de lamelles d'algues marines
100 g de riz
10 g de chapelure
sel

Dans une casserole d'eau salée, cuire le riz 15 minutes puis le retirer du feu et laisser reposer 10 minutes. Égoutter et laisser refroicir. Paner l'écrevisse dans le pain et la frire. Hacher l'avocat. Poser les lamelles d'algues sur une table en bois. Mélanger le riz avec l'avocat haché et étaler une couche de la préparation sur les algues. Éliminer la tête et la queue de l'écrevisse et la disposer sur la couche de riz. Enrouler les algues sur elles-mêmes de sorte que l'écrevisse reste au centre et afin de former un cylindre compact. Couper le cylindre en portions de 2 cm.
Présentation : servir dans un plat et décorer de la tête et de la queue de l'écrevisse.

1 langostino
1/2 aguacate
30 g de láminas de algas marinas
100 g de arroz
10 g de pan rallado
sal

En una cazuela con agua y sal, cocer el arroz durante 15 minutos; luego retirar del fuego y dejar reposar durante 10 minutos. Escurrir y dejar enfriar. Rebozar el langostino en el pan rallado y freírlo. Picar el aguacate. Poner las láminas de algas sobre una tabla de madera, mezclar el arroz con el aguacate picado y colocar una capa del preparado sobre las algas. Eliminar la cabeza y la cola del langostino y colocarlo encima de la capa de arroz. Enrollar las algas sobre sí misma de manera que el langostino quede en el centro y formar un cilindro compacto. Cortar el cilindro en porciones de unos 2 cm.
Emplatado: Servir en plato llano y adornar con la cabeza y la cola del langostino.

1 gamberetto
1/2 avocado
30 g di lamine di alghe marine
100 g di riso
10 g di pan grattato
sale

In una pentola con acqua e sale, cuocere il riso per 15 minuti; dopodiché ritirare dal fuoco e lasciare a riposo per 10 minuti. Scolare e far raffreddare. Impanare il gamberetto nel pan grattato e friggerlo. Tritare l'avocado. Sistemare le lamine d'alga su un tagliere di legno, a parte mescolare il riso con l'avocado tritato e sistemare uno strato del preparato sulle alghe. Eliminare la testa e la coda del gamberetto e collocarlo sopra lo strato di riso. Avvolgere le alghe su se stesse in modo tale che il gamberetto rimanga al centro e si formi un cilindro compatto. Tagliare il cilindro in porzioni di circa 2 cm.
Presentazione: servire in un piatto piano e decorare con la testa e la coda del gamberetto.

Laris

Design: Michael Graves | Chef: David Laris

3 Zhong Shan Dong Yi Lu, No. 3 The Bund, 6th Floor | 200002 Shanghai
Phone: +86 21 6321 9922
www.threeonthebund.com
Subway: He Nan Zhong Lu
Opening hours: Every day 11:30 am to 2:30 pm, and 6 pm to 10:30 pm
Average price: € 45–55
Cuisine: New World

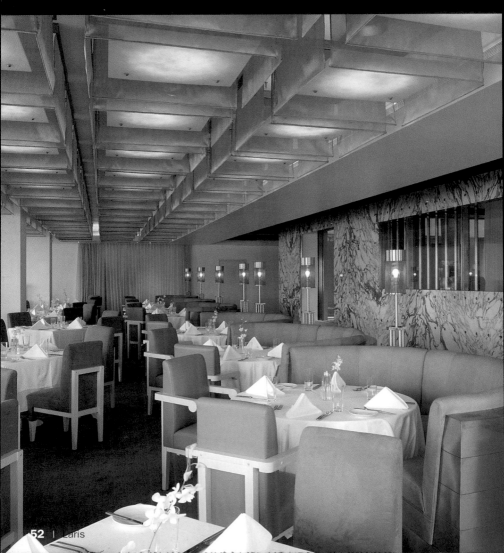

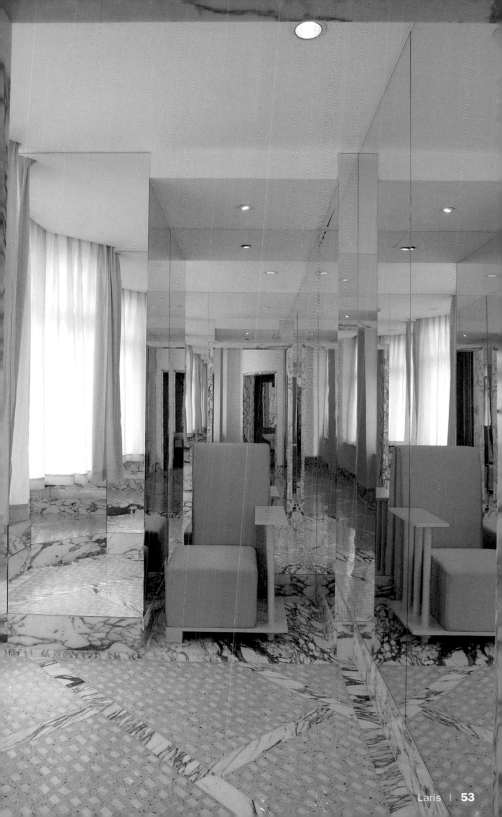

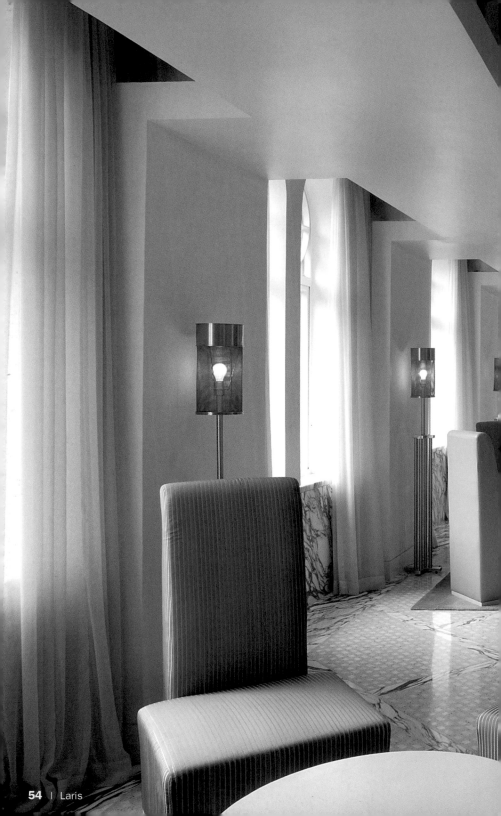

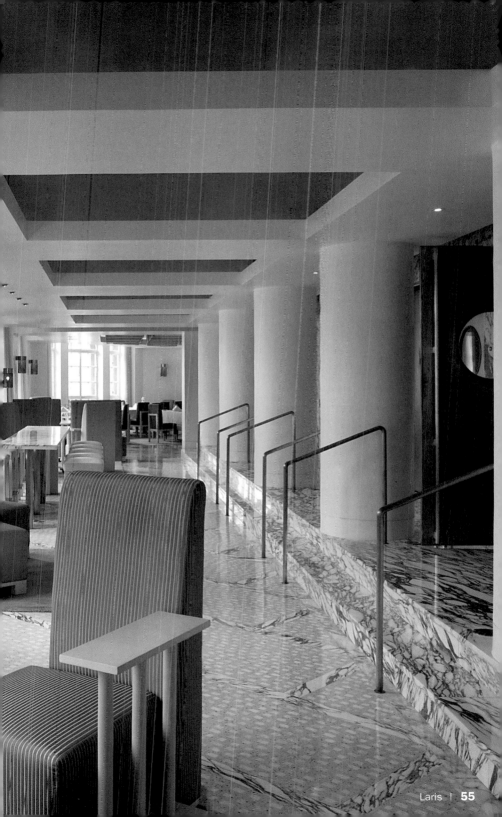

Crab

with Avocado Sauce

Krebs in Avocadosauce

Crabe à la sauce d'avocats

Cangrejo con salsa de aguacate

Granchio con salsa di avocado

1 pepper
1 cucumber
12 oz cherry tomatoes
1 chili pepper
2 leaves lemon balm
50 ml virgin olive oil
4 fresh limes
2 avocados
1 1/2 oz onion
1/2 oz coriander
1/2 oz basil
1 lb mashed crab meat
1 oz mayonnaise
Salt and black pepper

For the gazpacho: wash the pepper, cucumber and cherry tomatoes, chop into small pieces and liquidize. Add the chili pepper and chopped lemon balm leaves and liquidize again making sure no lumps remain. Add the olive oil and blend, then season with salt, black pepper and the juice of one lime. Lastly, filter the gazpacho through a fine sieve and leave to cool in the fridge.

For the avocado sauce: peel and dice the avocados and mix with the finely chopped onion and herbs (coriander and basil). Season with salt and the juice of two limes.

Season the crab meat apart with salt, black pepper and the juice of the remaining lime and blend with the mayonnaise.

To serve: place a circular mould in the middle of the plate and pour in the avocado sauce and the previously seasoned crab meat. Then pour the gazpacho onto the plate outside the mould. Remove the mould and decorate the crab with fresh coriander leaves.

1 Paprikaschote
1 Gurke
350 g Cherrytomaten
1 Chili
2 Blätter Zitronengras
50 ml naturreines Olivenöl
4 Limetten
2 Avocados
40 g Zwiebel
15 g Korianderblätter
15 g Basilikumblätter
500 g gehacktes Krebsfleisch
30 g Mayonnaise
Salz und schwarzer Pfeffer

Für den Gazpacho, die Paprikaschote, die Gurke und die Cherrytomaten waschen, in kleine Stücke schneiden und zu einer Suppe mixen. Die gehackte Chili und Zitronengras hinzufügen und wieder mixen, bis keine Klumpen mehr vorhanden sind. Das Olivenöl hinzufügen und schlagen, dann mit Salz, schwarzem Pfeffer und dem Saft einer Limette abschmecken. Schließlich den Gazpacho durch ein feines Sieb seihen und im Kühlschrank abkühlen lassen.

Für die Avocadosauce: Die Avocados schälen und in Würfel schneiden, mit der Zwiebel und den fein gehackten Gewürzkräutern (Koriander und Basilikum) mischen. Mit Salz und dem Saft von zwei Limetten abschmecken.

Das Krebsfleisch mit Salz, schwarzem Pfeffer und dem Saft einer Limette würzen und mit der Mayonnaise vermengen.

Anrichten: In die Mitte des Tellers eine runde Form stellen, in diese Form die Avocadosauce und das Krebsfleisch geben, um die Form herum den Gazpacho gießen. Form entfernen, mit frischen Korianderblättern dekorieren.

1 poivron
1 concombre
350 g de tomates cherry
1 chili
2 feuilles de citronnelle
50 ml d'huile d'olive vierge
4 citrons verts
2 avocats
40 g d'oignon
15 g de feuilles de coriandre
15 g de feuilles de basilic
500 g de pulpe de crabe haché
30 g de mayonnaise
Sel et poivre noir

Pour le gazpacho, laver le poivron, le concombre et les tomates cherry, les couper en petits morceaux et les passer au mixer. Ajouter le chili et les feuilles de citronnelle hachée et mixer à nouveau afin d'éliminer tous les grumeaux. Ajouter l'huile d'olive et battre puis assaisonner de sel, de poivre noir et du jus d'un citron vert frais. Passer finement le gazpacho dans un chinois fin et le laisser refroidir au réfrigérateur. Pour la sauce d'avocats, peler les avocats et les détailler en dés pour les mélanger avec l'oignon et les herbes aromatiques (coriandre et basilic) finement hachées. Assaisonner de sel et du jus de deux citrons verts frais.
À part, assaisonner la viande de crabe avec du sel, poivre noir et le jus d'un citron vert puis amalgamer avec la mayonnaise.
Présentation : disposer au centre d'un plat un moule circulaire, y verser la sauce d'avocats et la préparation de crabe puis verser le gazpacho autour. Retirer le moule et décorer de feuilles de coriandre fraîches.

1 pimiento
1 pepino
350 g de tomatitos cherry
1 chile
2 hojas de hierba limón
50 ml de aceite de oliva virgen
4 limas
2 aguacates
40 g de cebolla
15 g de hojas de cilantro
15 g de hojas de albahaca
500 g de pulpa de cangrejo picada
30 g de mayonesa
Sal y pimienta negra

Para el gazpacho, limpiar el pimiento, el pepino y los tomatitos cherry, cortarlos en trozos pequeños y licuarlos. Añadir el chile y las hojas de hierba limón picada y licuar nuevamente hasta eliminar todos los grumos. Añadir el aceite de oliva y batir, luego sazonar con sal, pimienta negra y zumo de una lima fresca. Finalmente, pasar el gazpacho por un tamiz de mallas finas y dejar enfriar en el frigorífico.
Para la salsa de aguacate, pelar los aguacates y cortarlo en dados, mezclarlo con la cebolla y con las hierbas aromáticas (cilantro y albahaca) finamente picadas. Aliñar con sal y zumo de dos limas frescas.
Aparte, sazonar la carne de cangrejo con sal, pimienta negra y zumo de una lima y amalgamar con la mayonesa.
Emplatado: disponeer en el centro de un plato un molde circular, verter en el molde la salsa de aguacate y el preparado de cangrejo; alrededor, verter el gazpacho. Quitar el molde y adornar con hojas frescas de cilantro.

1 peperone
1 cetriolo
350 g di pomodorini cherry
1 peperoncino piccante
2 foglie di erba cedrina
50 ml di olio extra vergine di oliva
4 limette
2 avocado
40 g di cipolla
15 g di foglie di coriandolo
15 g di foglie di basilico
500 g di polpa di granchio tritata
30 g di maionese
Sale e pepe nero

Per preparare il gazpacho di verdure, pulire il peperone, il cetriolo e i pomodorini cherry, tagliarli a pezzetti e schiacciarli fino a ridurli a liquido. Aggiungere il peperoncino piccante e le foglie di erba cedrina e liquefare nuovamente fino ad eliminare tutti i grumi. Aggiungere l'olio di oliva e sbattere, dopodiché condire con sale, pepe nero e succo di una limetta fresca. In ultimo, passare il gazpacho in un setaccio a maglie fini e lasciare raffreddare in frigorifero.
Per la salsa di avocado, pelare i avocado e tagliarli a dadi, mescolarli con la cipolla e con le erbe aromatiche (coriandolo e basilico) finemente tritate. Condire con sale e succo di due limette fresche.
A parte, insaporire la polpa di granchio con sale, pepe nero e succo di una limetta ed amalgamare con la maionese.
Presentazione: al centro di un piatto sistemare uno stampo circolare, versarvi la salsa di avocado e il preparato di granchio; tutto intorno, versare il gazpacho di verdure. Togliere lo stampo e decorare con foglie fresche di coriandolo.

Unit 1, House 16, Lane 181, Taicang Lu, North Block, Xitiandi Plaza | 200021 Shanghai
Phone: +86 21 6336 1717
www.lunashanghai.com.cn
Subway: Huang Pi Nan Lu
Opening hours: Every day 11:30 am to 2 am
Average price: € 14
Cuisine: Mediterranean
Special features: Complete wine menu

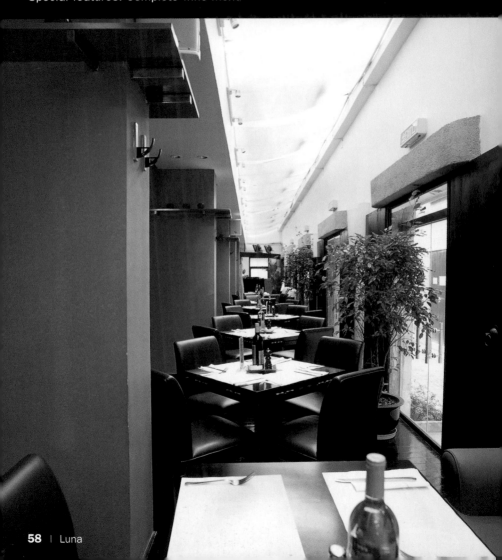

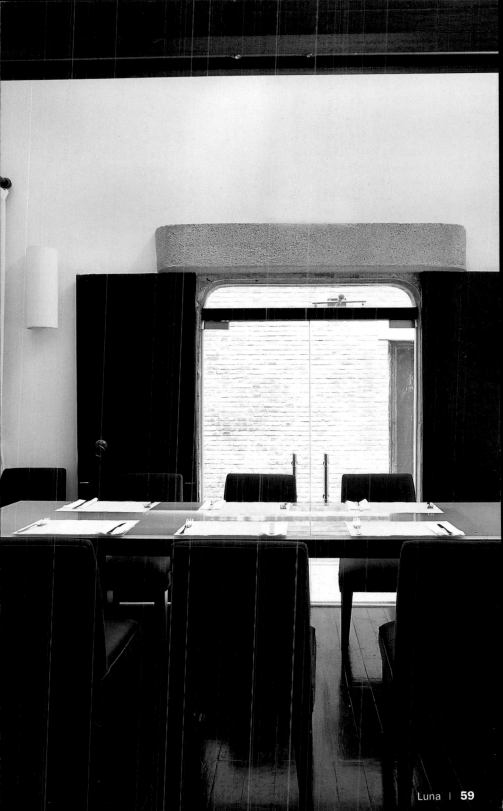

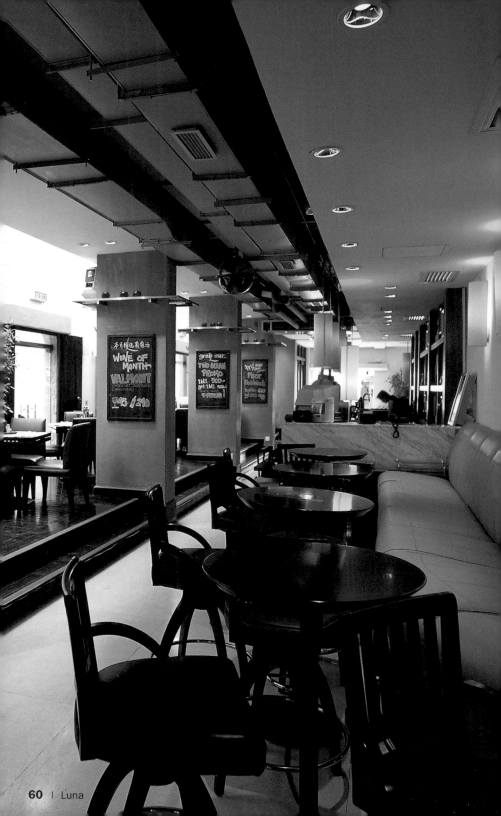

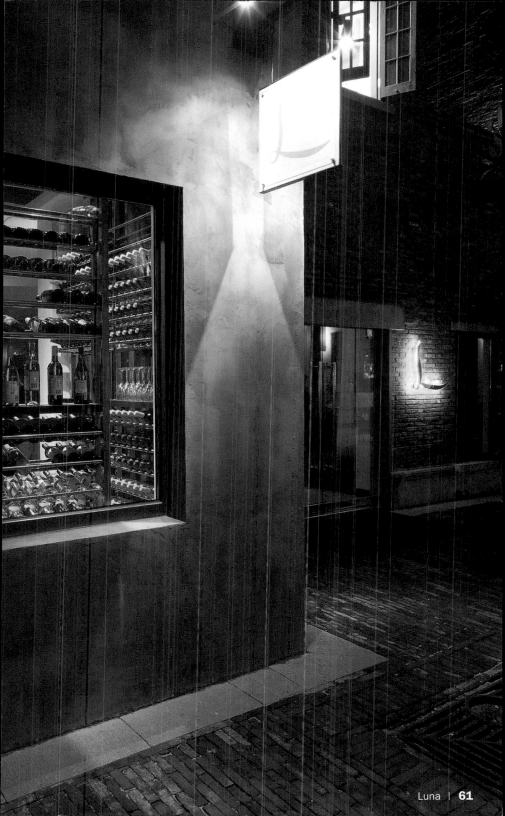

New Heights

Design: Michael Graves | Chef: Brad Turley

3 Zhong Shan Dong Yi Lu, No. 3 Bund, 7th Floor | 200002 Shanghai
Phone: +86 21 6321 0909
www.threeonthebund.com
Subway: He Nan Zhong Lu
Opening hours: Every day 10 am to 2 am
Average price: € 28–33
Cuisine: New World Dishes, including familiar flavors and contemporary brasserie dishe
Special features: Astonishing views of Huangpu River

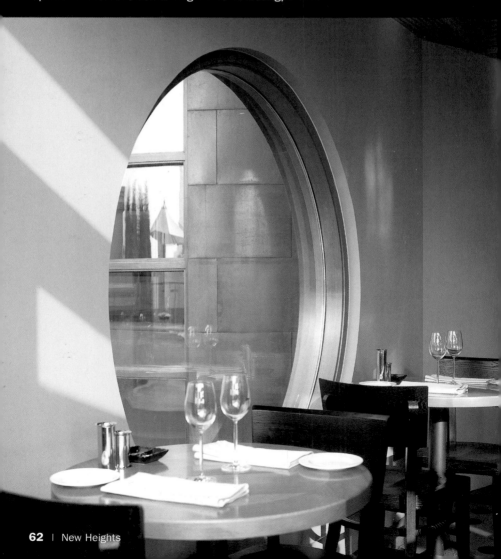

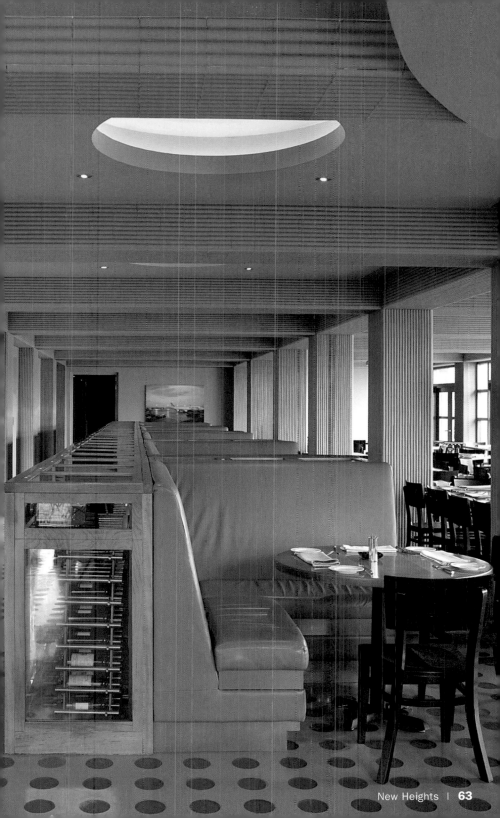

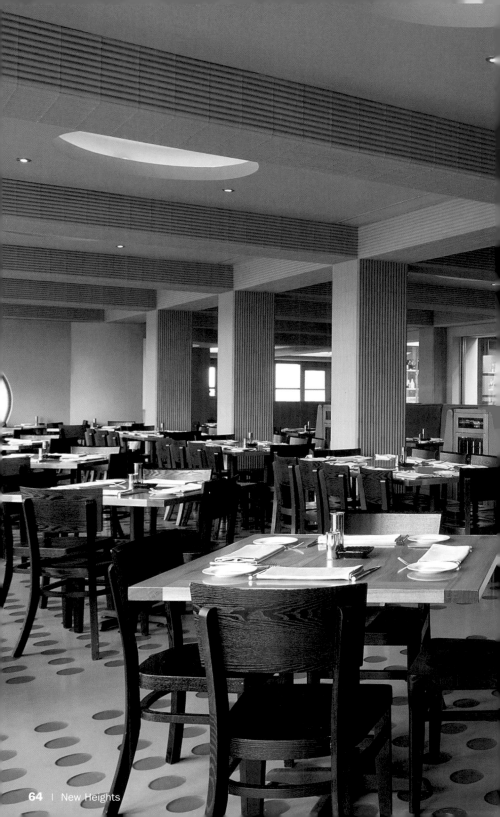

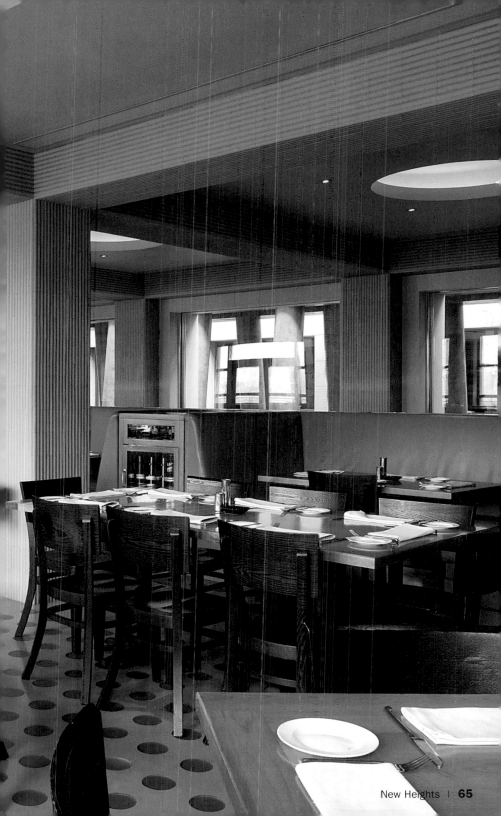

150 Yue Yang Lu I 200031 Shanghai
Phone: +86 21 6466 0505
shintori_sh@sina.com
Subway: Heng Shan Lu
Opening hours: Every day 11:30 am to 5:30 pm, and 6 pm to 12 pm
Average price: € 11
Cuisine: Innovative Chinese
Special features: Clean and minimalistics interiors

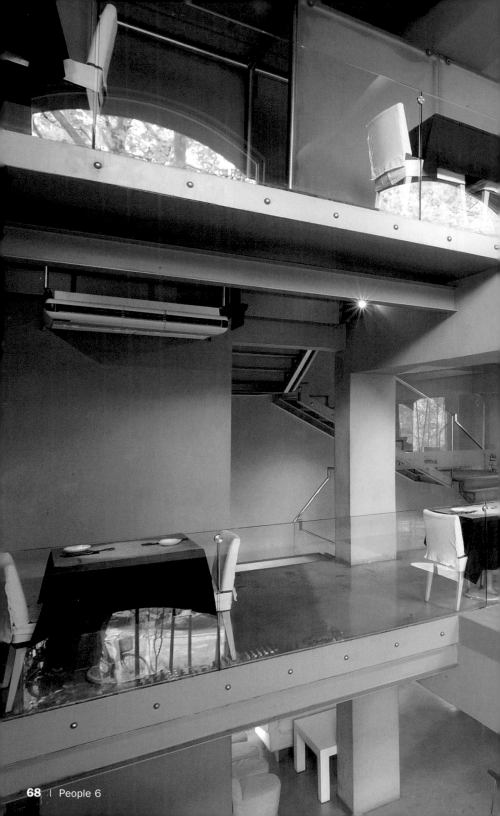

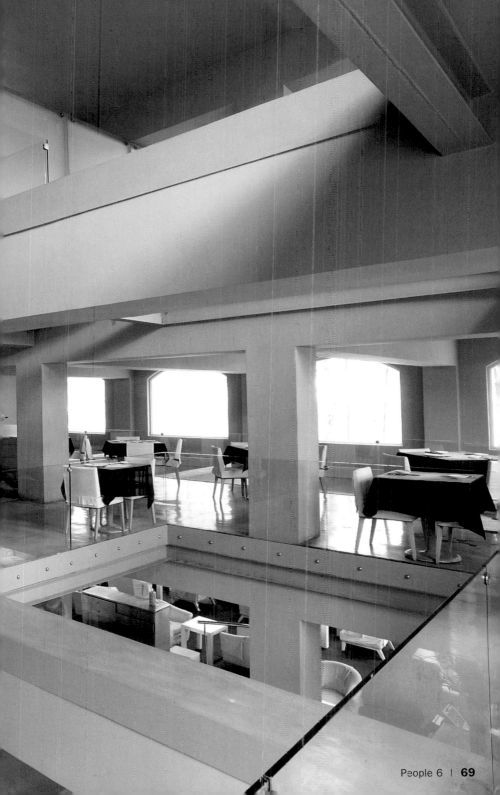

San Qian Yuan

Design: Kunyan Deng

64 Wulumuqi Nan Lu I 200030 Shanghai
Phone: +86 21 6474 3000
Subway: Heng Shan Lu
Opening hours: Every day 11:30 am to 11:30 pm
Average price: € 9
Cuisine: Innovative Gourmet
Special features: Reminiscences of traditional Chinese architecture

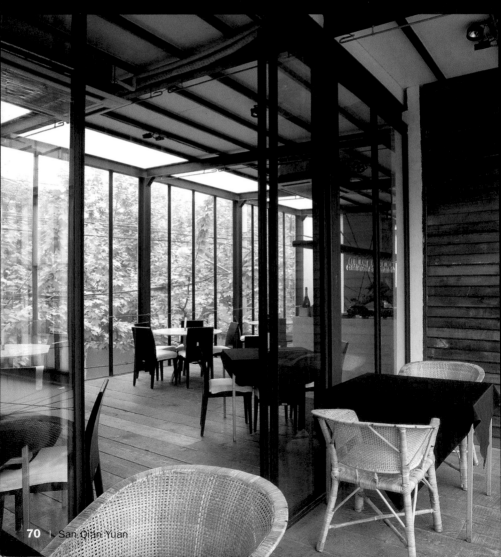

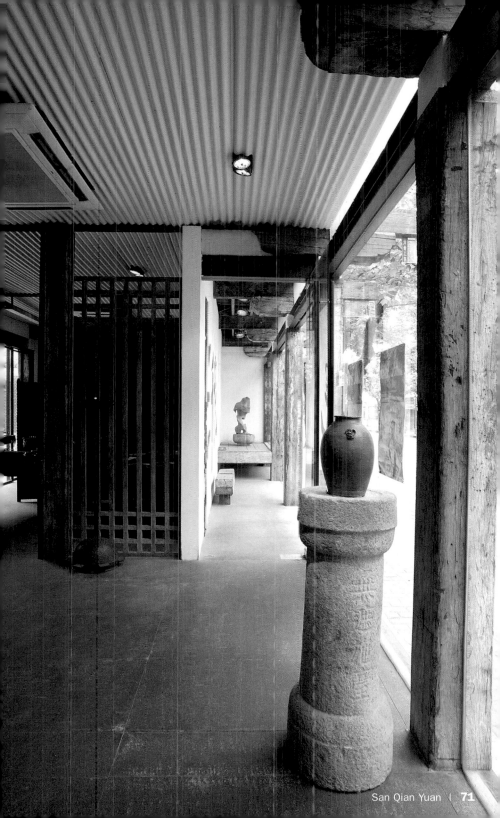

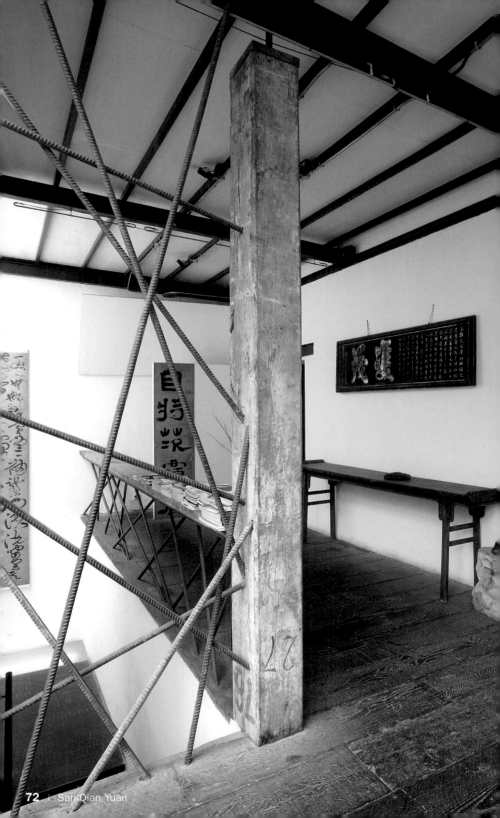

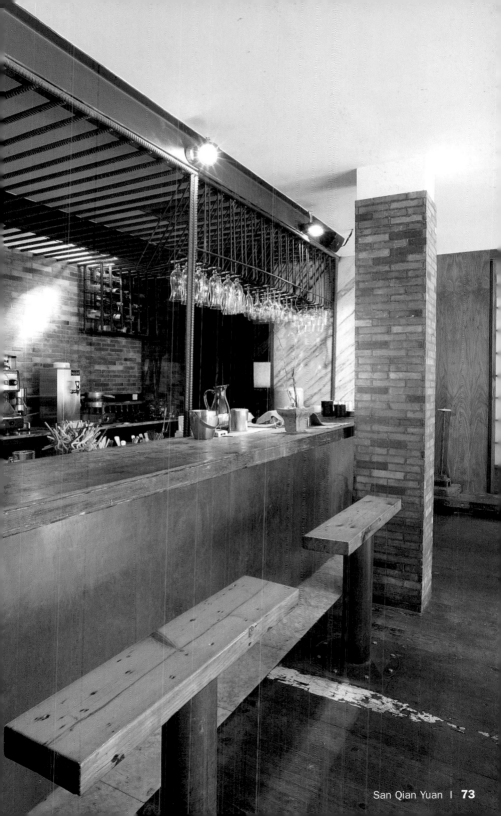

Lobster
and Mango Salad

Langusten-Mango-Salat
Salade de langouste et de mangues
Ensalada de langosta y mango
Insalata di aragosta e mango

1 lobster (c. 1lb)
6 small mangos
2 egg yolks
The juice of half a lemon
150 ml olive oil
2/3 oz soya
1 small tomato
1 sprig parsley
Salt

Prepare a mayonnaise by beating the yolks with salt and the lemon juice. When thick, add the oil gradually and beat constantly to a whipped consistency. Reserve. Boil the lobster in salted water for 15 minutes. Allow to cool and then remove the meat. Finely dice two of the mangos and blend, together with the lobster pulp, with the mayonnaise. Cut the remaining four mangos in half and spread with the lobster and mayonnaise mixture.
To serve: sprinkle the bottom of a platter with the soya and place the lobster shell in the middle. Crown with the half mangos and decorate with the tomato cut in half and the sprig of parsley.

1 Languste von 500 g
6 kleine Mangos
2 Eigelb
Saft einer halben Zitrone
150 ml Olivenöl
20 g Soja
1 kleine Tomate
1 Stengel Petersilie
Salz

Durch Schlagen von Eigelb mit Salz und Zitronensaft wird eine Mayonnaise zubereitet. Sobald diese Masse dick geworden ist, Tropfen für Tropfen Öl hinzufügen und weiterschlagen, bis die Mayonnaise steif ist. Zur Seite stellen. Die Languste in Salzwasser 15 Minuten kochen. Abkühlen lassen, dann das Langustenfleisch entnehmen. Zwei Mangos in kleine Würfel schneiden und zusammen mit dem gehackten Langustenfleisch mit der Mayonnaise mischen. Die anderen vier Mangos in zwei Teile schneiden und mit der Mayonnaisen-Langustenzubereitung füllen.
Anrichten: Soja in einer Schüssel verteilen, und in die Mitte den Panzer der Languste legen. Mit den Mangohälften krönen und mit einer in der Mitte zerteilten Tomate und dem Petersilienzweig dekorieren.

1 langouste de 500 g
6 petites mangues
2 jaunes d'œuf
Le jus d'un demi citron
150 ml d'huile d'olive
20 g de soja
1 petite tomate
1 brin de persil
sel

Préparer la mayonnaise en battant les jaunes avec le sel et le jus de citron. Une fois épaissie, ajouter l'huile peu à peu et battre afin de la faire monter. Réserver. Cuire la langouste dans de l'eau salée pendant 15 minutes. La laisser refroidir puis en extraire la pulpe. Couper deux mangues en petits dés et les amalgamer avec la pulpe de la langouste hachée et la mayonnaise. Couper les quatre mangues restantes en deux et les monter avec la préparation de mayonnaise et de langouste.
Présentation : disposer au fond d'un plat creux le soja et, au centre, la carapace de la langouste. Couronner des moitiés de mangues et décorer de la tomate coupée en deux et du brin de persil.

1 langosta de 500 g
6 mangos pequeños
2 yemas de huevo
zumo de medio limón
150 ml de aceite de oliva
20 g de soja
1 tomate pequeño
1 rama de perejil
sal

Preparar la moyonesa batiendo las yemas de huevo con sal y el zumo de limón. Cuando se haya espesado, añadir el aceite poco a poco y batir hasta que la mayonesa se monte. Reservar. Cocer la langosta en agua con sal durante 15 minutos. Dejarla enfriar, luego sacar la pulpa. Cortar dos mangos en daditos pequeños y amalgamarlos, junto con la pulpa de la langosta picada, con la mayonesa. Cortar los cuatro mangos restantes por la mitad y montarlos con el preparado de mayonesa y langosta.
Emplatado: disponer en el fondo de una fuente la soja y, en el centro, el caparazón de la langosta. Coronar con la mitades de mango y adornar con un tomate cortado por la mitad y una rama de perejil.

1 aragosta da 500 g
6 manghi piccoli
2 tuorli d'uovo
succo di mezzo limone
150 ml di olio d'oliva
20 g di soia
1 pomodoro piccolo
1 rametto di prezzemolo
sale

Preparare la maionese sbattendo i tuorli d'uovo con il sale e il succo di limone. Quando il composto si sarà ispessito, aggiungere l'olio poco a poco e sbattere fino a montare a neve la maionese. Mettere da parte. Cuocere l'aragosta in acqua e sale per 15 minuti. Lasciarla raffreddare, dopodiché estrarre la polpa. Tagliare due manghi a dadini ed amalgamarli assieme alla polpa di aragosta tritata e alla maionese. Tagliare gli altri manghi a metà e montarli con il preparato di maionese ed aragosta.
Presentazione: disporre sul fondo di un vassoio la soia e al centro il guscio dell'aragosta. Coronare con le metà dei manghi e decorare con un pomodoro tagliato a metà e un rametto di prezzemolo.

Sens & Bund

Design: Imaad Rahmouni | Chef: J&L Pourcel

18 Zhong Shan Dong Yi Lu, Bund 18, 6th Floor | 200002 Shanghai
Phone: +86 21 6323 9898
Subway: He Nan Zhong Lu
Opening hours: Every day 11:30 am to 2:30 pm, and 6:30 pm to 10:30 pm
Average price: Lunch € 28–38, Dinner € 56–75
Cuisine: French
Special features: Romantic French–inspired decoration

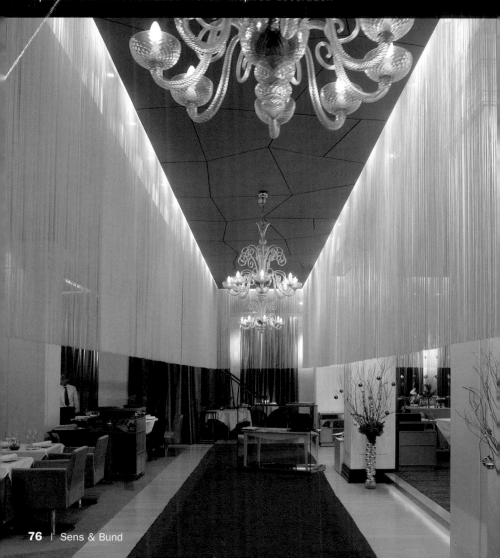

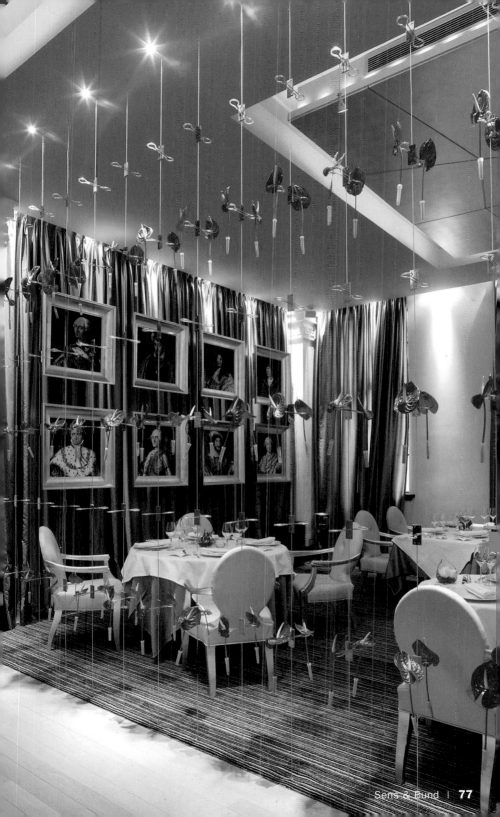

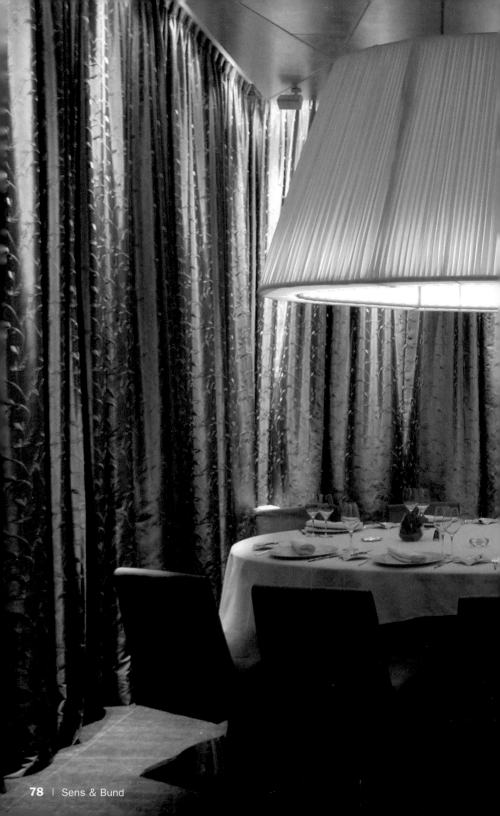

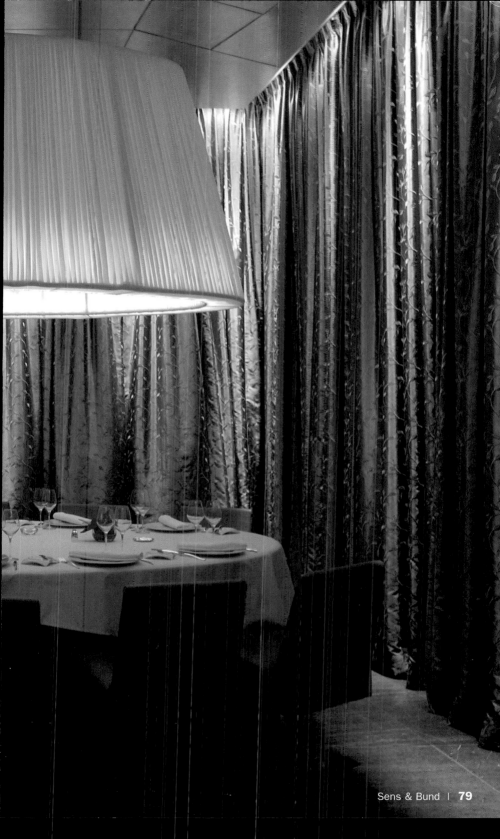

Sea Bass

with Asparagus

Seebarsch mit grünem Spargel

Bar aux asperges

Lubina con espárragos

Branzino con asparagi

1 sea bass (c. 3 lb)
16 large asparagus
100 ml olive oil
2 lemons
3 shallots
1 sprig chervil
Salt and pepper

Cut the fish into fillets of approx. 5 1/2 oz each. Wash the asparagus, peel and boil them in salted water for 10 minutes. Then remove from the water and cover with ice so that they remain green and fresh. Pre-heat the oven to 275 °F, season the bass fillets with olive oil, salt and pepper and bake for 12 minutes. Dice one of the lemons and mix with the olive oil, the juice of the other lemon and the finely chopped shallots. Re heat the asparagus in water.

To serve: smear the bottom of the plate with butter, place the asparagus side-by-side, put a fish fillet on top and bathe with the lemon sauce. Decorate with lemon slices and a sprig of chervil.

1 Seebarsch mit 1,5 kg
16 große grüne Spargelstangen
100 ml Olivenöl
2 Zitronen
3 Schalotten
1 Kerbelzweig
Salz und Pfeffer

Den Seebarsch in mehrere Filets von ca. 160 g schneiden. Den Spargel waschen, schälen und 10 Minuten in Salzwasser kochen, dann herausnehmen und in Eis legen, damit er grün und frisch bleibt. Die Seebarschfilets mit Olivenöl, Salz und Pfeffer würzen und im auf 140 °C vorgeheizten Backofen 12 Minuten backen. Eine Zitrone in Würfel schneiden und mit dem Olivenöl, dem Saft der anderen Zitrone und fein gewürfelten Schalotten mischen. Den Spargel in Wasser erwärmen.

Anrichten: Spargel auf einem mit Butter eingeriebenem Teller nebeneinander anrichten, das Filet auf den Spargel legen und mit der Zitronensauce übergießen. Mit Zitronenscheiben und dem Kerbelzweig dekorieren.

bar de 1,5 kg
16 grandes asperges
100 ml d'huile d'olive
2 citrons
3 échalotes
1 brin de cerfeuil
sel et poivre

Couper le bar en plusieurs filets de 160 g. Laver les asperges, les peler et les faire bouillir dans de l'eau salée pendant 10 minutes. Sortir les asperges et les poser dans de la glace pour les maintenir vertes et fraîches. Griller les filets de bar dans l'huile d'olive, le sel et le poivre au four préchauffé à 140 °C durant 12 minutes. Couper le citron en dés et les mélanger avec l'huile d'olive, le jus de l'autre citron et les échalotes finement émincées. Réchauffer les asperges dans l'eau.
Présentation : sur le fond d'un plat beurré, ranger les asperges, accommoder le filet dessus et arroser de la sauce au citron. Décorer de tranches de citron et d'un brin de cerfeuil.

1 lubina de 1,5 kg
16 espárragos grandes
100 ml de aceite de oliva
2 limones
3 chalotas
1 rama de perifollo
Sal y pimienta

Cortar la lubina en varios filetes de unos 160 g. Lavar los espárragos, pelarlos y hervirlos en agua con sal durante 10 minutos, sacarlos y ponerlos en hielo para que se mantengan verdes y frescos. Asar los filetes de lubina con aceite de oliva, sal y pimienta en el horno precalentado a 140 °C durante 12 minutos. Cortar un limón en dados y mezclarlo con el aceite de oliva, el zumo de otro limón y las chalotas cortadas muy finamente. Volver a calentar los espárragos en agua.
Emplatado: Sobre el fondo de un plato untado con mantequilla, disponer los espárragos uno al lado de otro, acomodar el filete encima y bañar con la salsa de limón. Adornar con rodajas de limón y una rama de perifollo.

1 branzino da 1,5 kg
16 asparagi grandi
100 ml di olio d'oliva
2 limoni
3 scalogni
1 rametto di cerfoglio
Sale e pepe

Tagliare il branzino in diversi filetti di circa 160 g. Lavare gli asparagi, pelarli e farli bollire in acqua con sale per 10 minuti; quindi toglierli dal fuoco e sistemarli momentaneamente nel freezer affinché rimangano verdi e freschi. Nel forno preriscaldato a 140 °C cuocere il filetto di branzino con olio di oliva, sale e pepe per 12 minuti. Tagliare un limone a dadini e mescolarlo con l'olio di oliva, il succo di un altro limone e gli scalogni tagliati molto finemente. Rimettere sul fuoco gli asparagi per farli riscaldare.
Presentazione: sul fondo di un piatto imburrato, disporre gli asparagi uno accanto all'altro, adagiarvi sopra il filetto e bagnare con la salsa di limone. Decorare con rondelle di limone e un rametto di cerfoglio.

Villa 11, 118 Ruijin Er Lu, Ruijin Guest House I 200020 Shanghai
Phone: +86 21 5466 0159
www.7colours.cn
Subway: Shan Xi Nan Lu
Opening hours: 10 am to 2 am
Average price: € 23
Cuisine: French Fusion
Special features: Beautiful interior, terrace with garden

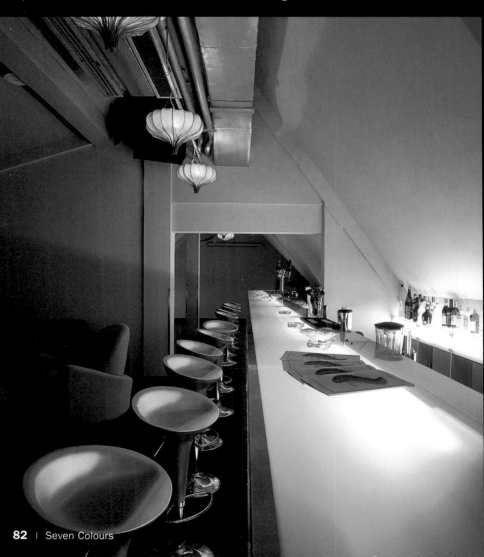

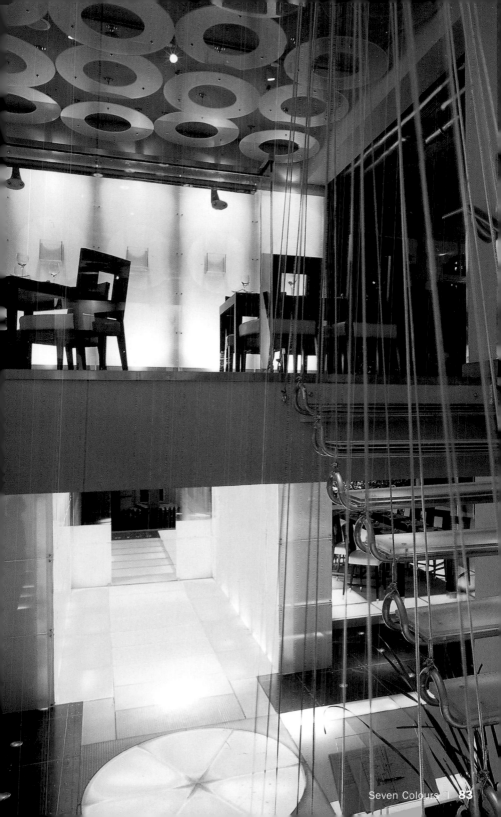

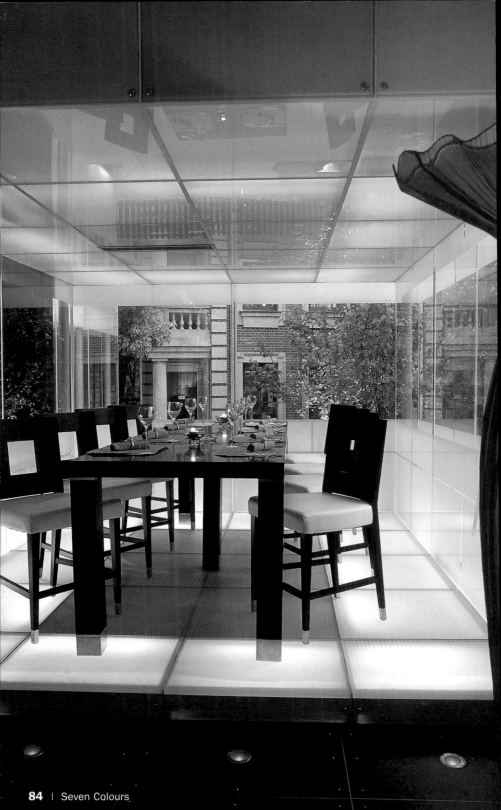

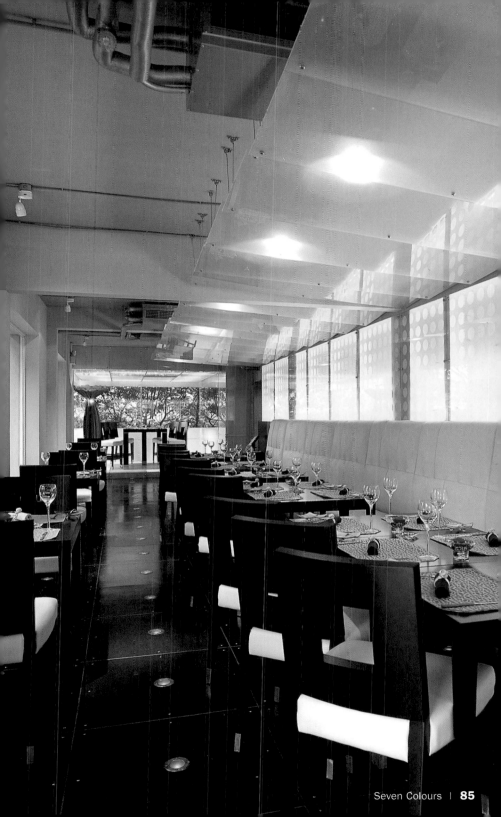

Salmon

with Asparagus

Lachs mit grünem Spargel

Saumon aux asperges

Salmón con espárragos

Salmone con asparagi

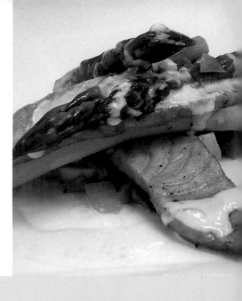

2 salmon fillets (4 oz)
2/3 oz dried mushrooms
3 asparagus
1 oz XO sauce
1 1/2 oz chives
1 onion
150 ml white wine
100 ml béchamel
200 ml olive oil

Gently fry the salmon fillets in olive oil and reserve. In another pan, fry the asparagus with the chopped onion and chives. Add the mushrooms and fry for a further 5 minutes. Add the wine, XO sauce and béchamel and reduce for 2 minutes over a low flame.
To serve: arrange the mushrooms in the middle of a plate. Place the salmon and asparagus alternately on top. Bathe with the sauce and serve hot.

2 Lachsfilets (120 g)
20 getrocknete Pilze
3 grüne Spargelstangen
30 g Xo-Sauce
50 g Schnittlauch
1 Zwiebel
150 ml Weißwein
100 ml Béchamelsauce
200 ml Olivenöl

In einer Pfanne die Lachsfilets in Olivenöl auf kleiner Flamme anbraten. Zur Seite stellen. In einer anderen Pfanne den Spargel mit der gehackten Zwiebel und den Schnittlauch anbraten. Die Pilze hinzugeben und 5 Minuten anbraten. Den Weißwein, die Xo-Sauce und die Béchamelsauce hinzugeben und 2 Minuten auf kleiner Flamme reduzieren lassen.
Anrichten: Die Pilze in die Mitte eines flachen Tellers geben. Darüber abwechselnd Lachsfilets und Spargel anordnen. Mit der Sauce übergießen und heiß servieren.

2 pièces de filet de saumon (120 g)
20 g de champignons secs
3 asperges
30 g de sauce Xo
50 g de ciboulette
1 oignon
150 ml de vin blanc
100 ml de béchamel
200 ml d'huile d'olive

À la poêle, faire frire à feu doux les pièces de saumon dans l'huile d'olive. Réserver. Faire frire, dans l'autre poêle, les asperges avec l'oignon et la ciboule hachés. Ajouter les champignons et laisser frire 5 minutes. Ajouter le vin blanc, la sauce Xo et la béchamel puis laisser réduire 2 minutes à feu doux.
Présentation : disposer les champignons au centre d'un plat. Les couvrir des pièces de saumon en les faisant alterner avec les asperges. Baigner de béchamel et servir chaud.

2 piezas de filete de salmón (120 g)
20 g de setas secas
3 espárragos
30 g de salsa Xo
50 g de cebollino
1 cebolla
150 ml de vino blanco
100 ml de bechamel
200 ml aceite de oliva

En una sartén, freír las piezas de salmón en aceite de oliva a fuego medio. Reservar. Freír, en otra sartén, los espárragos con cebolla y cebollino picados. Añadir las setas y freír durante 5 minutos. Agregar el vino blanco, la salsa Xo y la bechamel y reducir por 2 minutos a fuego lento.
Emplatado: Disponer en el centro de un plato llano las setas. Colocar encima las piezas de salmón alternándolas con los espárragos. Bañar con bechamel y servir caliente.

2 pezzi di filetto di salmone (120 g)
20 g di funghi secchi
3 asparagi
30 g di salsa Xo
50 g di herba cipollina
1 cipolla
150 ml di vino bianco
100 ml di besciamella
200 ml di olio di oliva

In una padella, friggere i pezzi di salmone in olio di oliva a fuoco medio. Mettere da parte. In un'altra padella, friggere gli asparagi con la cipolla e il cipollino ben tritati. Unire i funghi e friggere per 5 minuti. Aggiungere il vino bianco, la salsa Xo e la besciamella e far ridurre per 2 minuti a fuoco lento.
Presentazione: al centro di un piatto piano sistemare i funghi. Su di questi adagiarvi alternatamente i pezzi di salmone e gli asparagi. Bagnare con la besciamella e servire caldo.

Shintori Null II

Design: Sakae Miura | Chef: Mengkai Zhang

803 Julu Lu | 200040 Shanghai
Phone: +86 21 5404 5252
Subway: Jing An Temple
Opening hours: Mon–Fri from 5:30 pm to 11 pm, Sat–Sun from 11:30 am to 2 pm
Average price: € 23
Cuisine: Japanese
Special features: Minimalist rehabilitation of a theatre

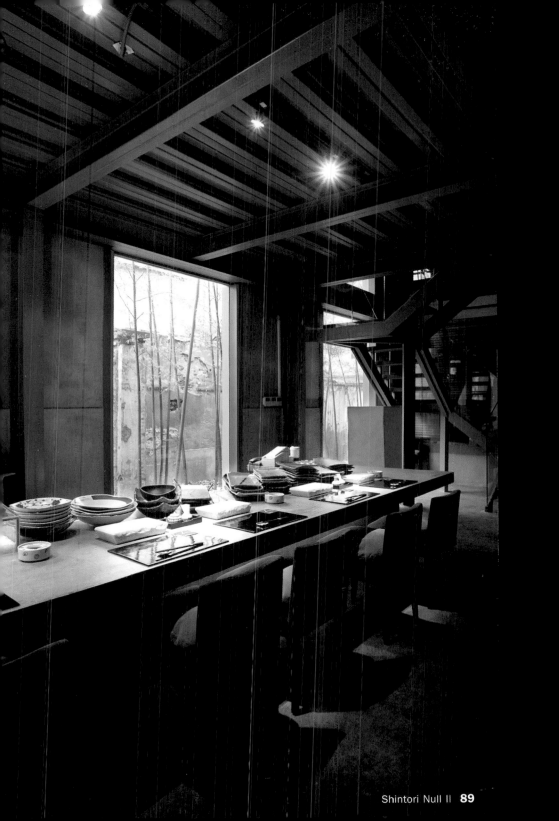

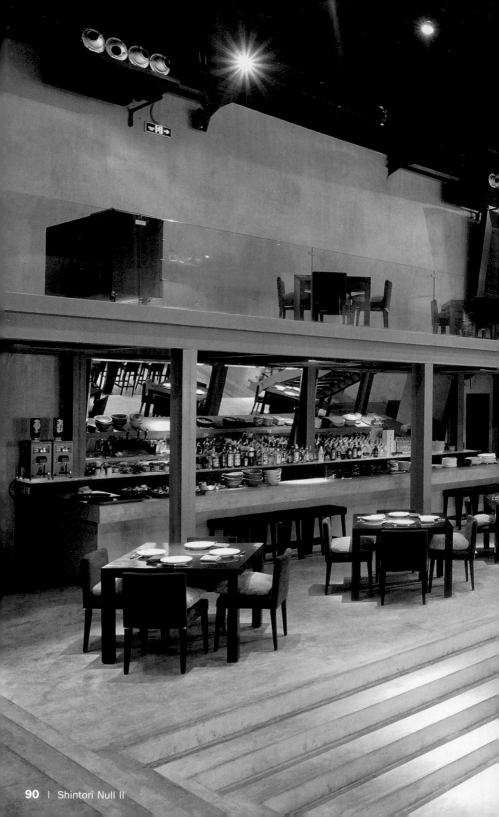

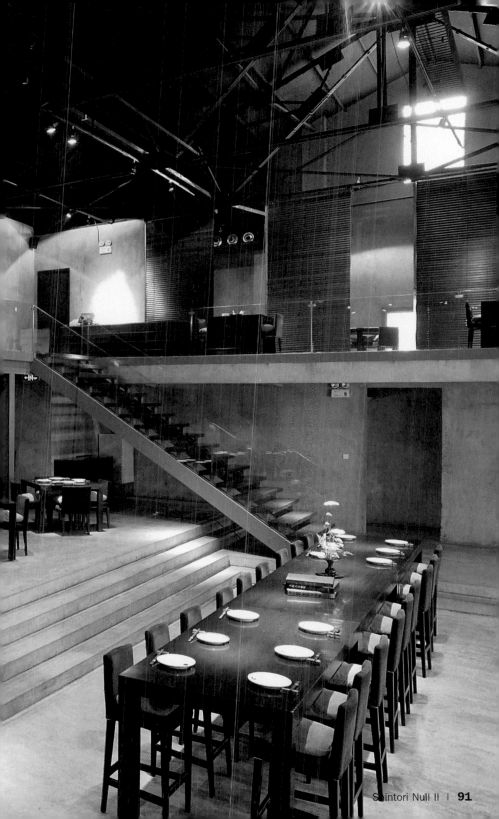

Soahc

Design: Lily Ho | Chef: Fulin Fang

House 3, Lane 123, Xingye Lu, South Block, Xintiandi Plaza | 200021 Shanghai
Phone: +86 21 6385 7788
www.xintiandi.com
Subway: Huang Pi Nan Lu
Opening hours: Every day 11:30 am to 14:30 pm, 15 am to 17 pm,
and 17:30 pm to 22:30 pm
Average price: € 23
Cuisine: Huai Yang & Sicuani
Special features: Classic furniture and sophisticated ambience

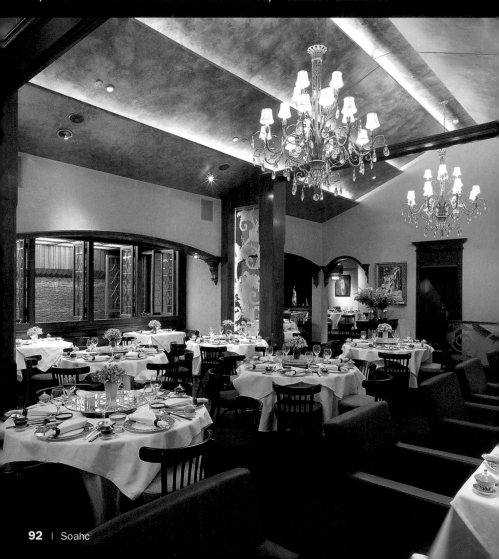

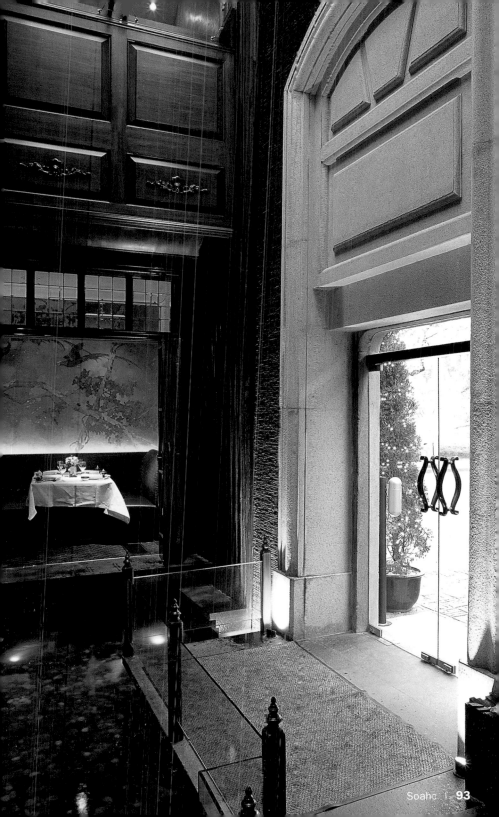

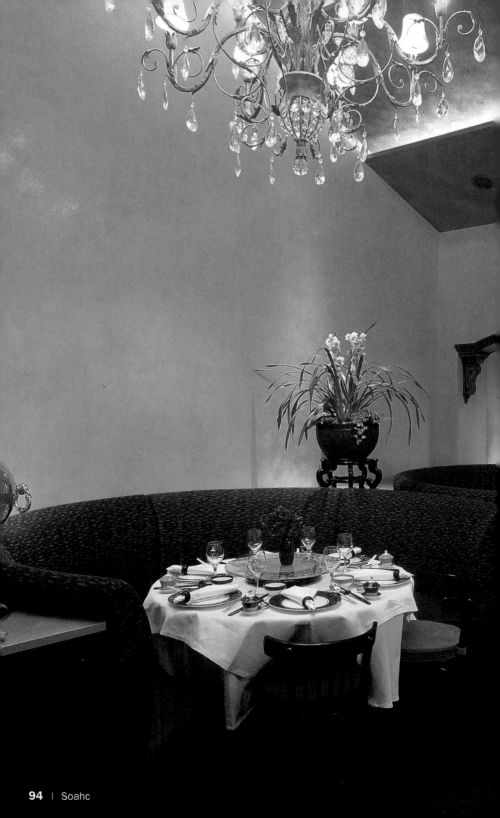

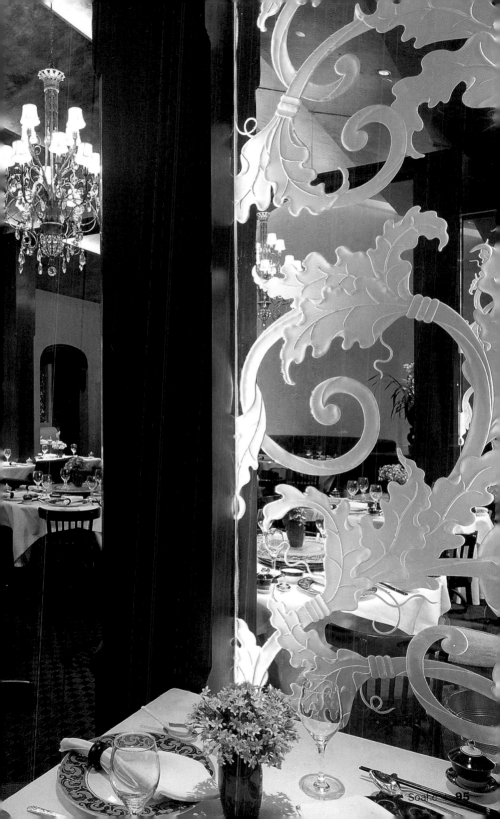

Longan flower

Longan-Blüte
Fleur de longan
Flor de longan
Fiore di longana

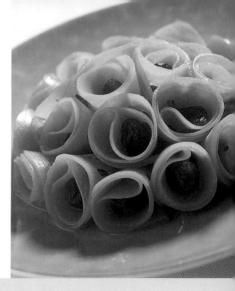

3 1/2 oz lotus root
1 3/4 oz longan
100 ml orange juice
The juice of 1 lemon

Choose a tender lotus root and cut into thin round slices of about the same size. Put the slices into boiling water for a few seconds, then remove and cool under the cold tap. Remove any remaining starch and dry in kitchen paper. Reserve. Mix the orange and lemon juice and pour into a deep receptacle. Marinate the lotu slices in the juice for 24 hours. Then dry i kitchen paper, fold into a cone shape and fi with longan pulp.
To serve: on a plate, arrange the cones in the form of a lotus flower.

100 g Lotuswurzeln
50 g Longan
100 ml Orangensaft
Saft von einer Zitrone

Eine zarte Lotuswurzel auswählen und in feine, runde Scheiben schneiden, die alle etwa gleich groß sein sollten. Einige Sekunden in kochendes Wasser geben, herausnehmen und unter reichlich fließendem Wasser abkühlen. Die Reste von Stärke entfernen und mit Küchenpapie trocknen. Zur Seite stellen. Den Orangensaft mi dem Zitronensaft mischen und in eine tiefe Schüssel geben. Die Lotusscheiben 24 Stunder in den Saft einlegen. Anschließend die Lotus wurzelstücke mit Küchenpapier trocknen, einer Kegel formen und diesen mit dem Fruchtfleisch der Longan, die vorher geschält wurde, füllen.
Anrichten: Die Kegel in Form einer Lotusblüte auf einem flachen Teller anordnen.

400 g de racines de lotus
50 g longan
100 ml de jus d'orange
le jus d'un citron

Choisir une racine de lotus tendre et l'émincer en lamelles rondes très fines, plus ou moins de la même épaisseur. Les plonger dans de l'eau bouillante durant quelques secondes, les retirer et les refroidir sous l'eau en abondance. Éliminer les restes d'amidon et sécher avec un papier absorbant. Réserver. Mélanger les jus d'orange et de citron et verser le tout dans un récipient creux. Laisser tremper les lamelles de lotus dans e jus pendant 24 heures. Ensuite, sécher les lamelles de racine de lotus avec un papier absorbant, les plier en cône et les remplir de pulpe de longan, préalablement pelé.
Présentation : dans un plat, disposer les cônes en forme de fleur de lotus.

400 g de raíces de loto
50 g longan
100 ml de zumo de naranja
zumo de un limón

Escoger una raíz de loto tierna y cortarla en láminas sutiles y redondas, más o menos del mismo tamaño. Ponerlas en agua hirviendo durante unos segundos, retirar y enfriar bajo abundante agua corriente. Eliminar los restos de almidón y secar con papel absorbente. Reservar. Mezclar el zumo de naranja con el de limón y verter la mezcla en un recipiente hondo. Dejar las láminas de loto a remojo en el zumo durante 24 horas. Después, secar los trozos de raíz de loto con papel absorbente, doblar en forma de cono y rellenar con pulpa de longan previamente pelado.
Emplatado: en un plato llano, disponer los conos en forma de flor de loto.

400 g di radici di loto
50 g di longana
100 ml di succo d'arancia
Succo di un limone

Selezionare una radice di loto tenera e tagliarla in lamine sottili e rotonde, più o meno delle stesse dimensioni. Immergetele per alcuni secondi in acqua bollente, quindi toglierle dal fuoco e farle raffreddare sotto abbondante acqua corrente. Eliminare i resti di amido e asciugare con carta assorbente. Mettere da parte. Mescolare il succo d'arancia con quello di limone e versare il tutto in un recipiente fondo. Lasciare le lamine di loto a mollo nel succo per 24 ore. Dopodiché, asciugare i pezzi di radice di loto con carta assorbente, piegare a forma di cono e riempire con la polpa di longana previamente pelata.
Presentazione: in un piatto piano, disporre i coni a forma di fiore di loto.

Tan Wai Lou

Design: Inmaad Rahmouni I Chef: Tao Zhihai

18 Zhong Shan Dong Yi Lu, 18 Bund, 5th floor I 200002 Shanghai
Phone: +86 21 6339 1188
Subway: He Nan Zhong Lu
Opening hours: 11 am to 2:30 pm, and 5:30 pm to 10:30 pm
Average price: Lunch € 24, Dinner € 47
Cuisine: Cantonese

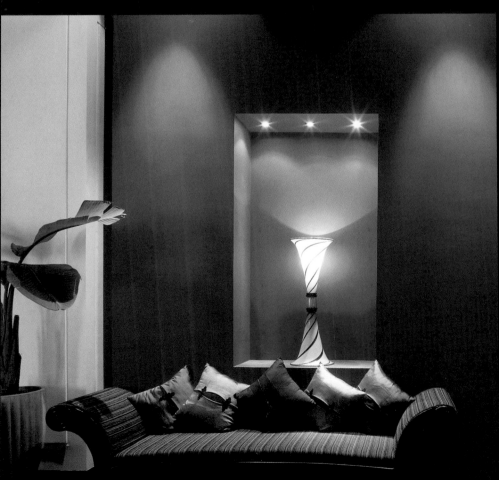

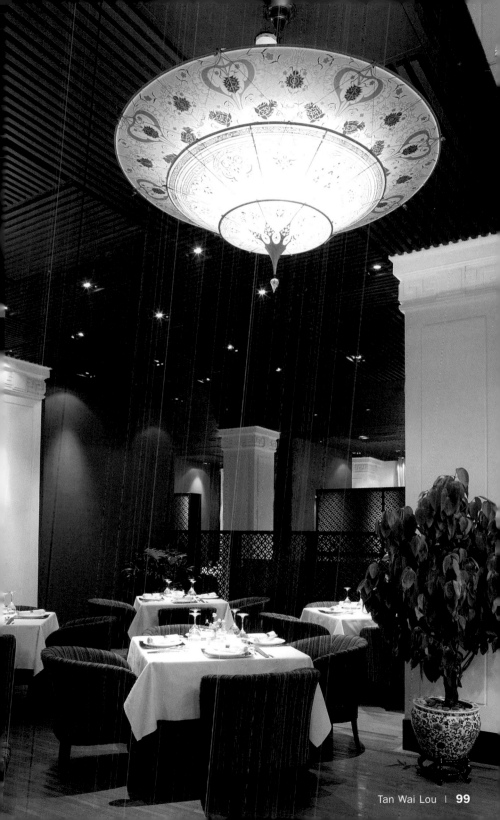

Tan Wai Lou | **99**

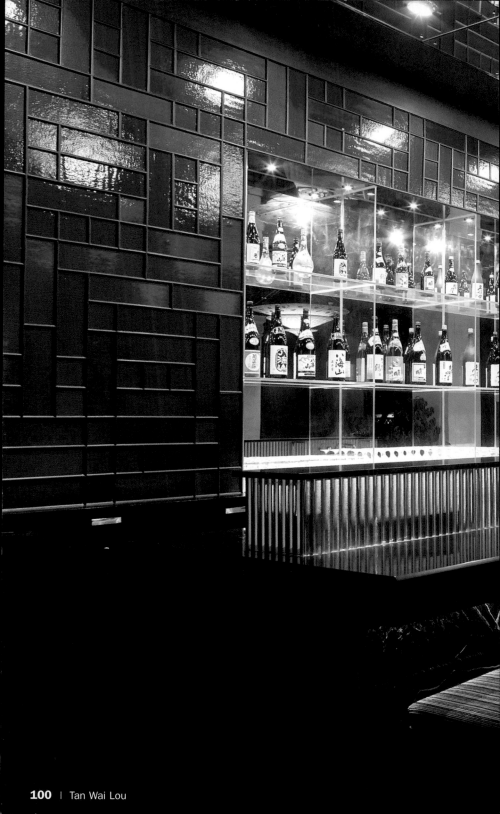

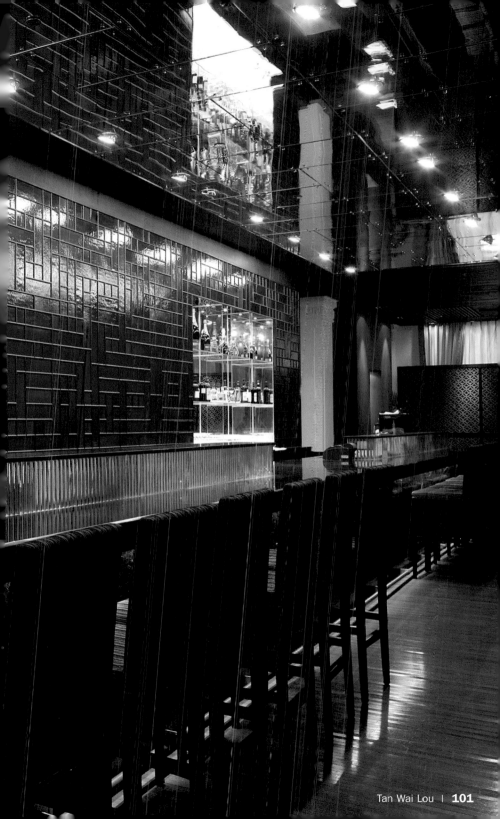

Crab

and Vegetable Rolls

Gemüse-Krebs-Rollen
Rouleaux de légumes et de crabe
Rollito de verduras y cangrejo
Involtini di verdure e granchio

1 asparagus
1 mustard leaf
2 bamboo shoots
1 lb crab meat
1 oz crab roe
1 3/4 oz chicken meat
100 ml chicken stock
1/6 oz starch

Mince the chicken and the bamboo shoots and mix them with the crab meat and 3/4 oz of the roe until an even consistency is reached. Wrap the asparagus and the rolled mustard leaves with this preparation and steam for 3 minutes. In another receptacle heat the chicken stock and the remaining roe for 10 minutes. Thicken with the starch.
To serve: arrange the asparagus and the mustard leaves on a plate and sprinkle with the hot stock.

1 grüner Spargel
1 Senfblatt
2 Bambussprossen
500 g Krebsfleisch
30 g Krebseier
50 g Hähnchenfleisch
100 ml Hühnerbrühe
5 g Stärke

Das Hähnchenfleisch und die Bambussprossen hacken und mit dem Krebsfleisch und 20 g Krebseiern mischen, bis eine einheitliche Masse entsteht. Den Spargel und die gerollten Senfblätter in die Masse einrollen und 3 Minuten lang dünsten. In einem anderen Topf die Hühnerbrühe und die übrigen Krebseier zehn Minuten lang erhitzen. Mit 5 g Stärke andicken.
Anrichten: Den Spargel und die Senfblätter auf einem Teller anrichten und mit der noch heißen Brühe benetzen.

1 asperge
1 feuille de moutarde
2 pousses de bambou
500 g de pulpe de crabe
30 g d'œufs de crabe
50 g de chair de poulet
100 ml de bouillon de poulet
5 g de fécule

Hacher la viande de poulet et les pousses de bambou et les mêler à la pulpe de crabe et à 20 g d'œufs de crabe pour obtenir une masse homogère. Envelopper l'asperge et les feuilles de moutardes enroulées avec la préparation et faire cuire 3 minutes à la vapeur. Dans un récipient à part, chauffer le bouillon de poulet et les œufs de crabe restants pendant 10 minutes. Épaissir avec 5 g de fécule.
Présentation : disposer les asperges et les feuilles de moutarde dans un plat et arroser avec le bouillon encore chaud.

1 espárrago
1 hoja de mostaza
2 brotes de bambú
500 g de pulpa de cangrejo
30 g de huevas de cangrejo
50 g de carne de pollo
100 ml de caldo de pollo
5 g de fécula

Picar la carne de pollo y los brotes de bambú y mezclarlos con la pulpa de cangrejo y 20 g de huevas hasta obtener una masa homogénea. Envolver el espárrago y las hoja de mostaza enrolladas con el preparado y cocer al vapor durante 3 minutos. En un recipiente aparte, calentar el caldo de pollo y las huevas de cangrejo que quedan durante 10 minutos. Espesar con 5 g de fécula.
Emplatado: Disponer en un plato los espárragos y las hojas de mostaza y rociar con el caldo aún caliente.

1 asparago
1 foglia di senape
2 germogli di bambù
500 g di polpa di granchio
30 g di uova di granchio
50 g di carne di pollo
100 ml di brodo di pollo
5 g di fecola

Tritare la carne di pollo e i germogli di bambù e mescolarli con la polpa di granchio e 20 g di uova fino ad ottenere un impasto omogeneo. Avvolgere l'asparago e le foglie di senape arrotolate con il preparato e cuocere al vapore per 3 minuti. In un recipiente a parte, riscaldare il brodo di pollo e le restanti uova di granchio per 10 minuti. Addensare con 5 g di fecola.
Presentazione: in un piatto disporre gli asparagi e le foglie di senape e spruzzarvi sopra il brodo ancora caldo.

House 7, Lane 181, Taicang Lu, North Block, Xintiandi Plaza | 200021 Shanghai
Phone: +86 21 6311 2211
www.xintiandi.com
Subway: Huang Pi Nan Lu
Opening hours: Sun–Thu 11:30 am to 3 pm, and 6 pm to 11 pm, Fri–Sat 6 pm
to 11:30 pm
Average price: € 27
Cuisine: Italian
Special features: Excentric decoration in an historic setting

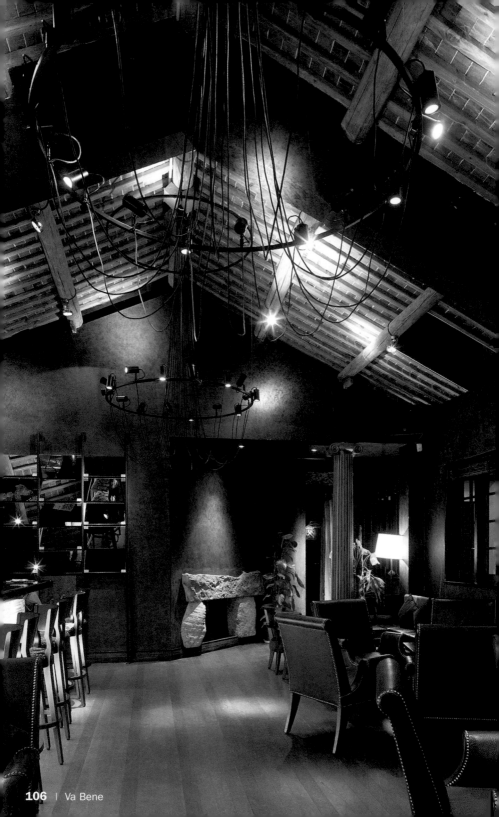

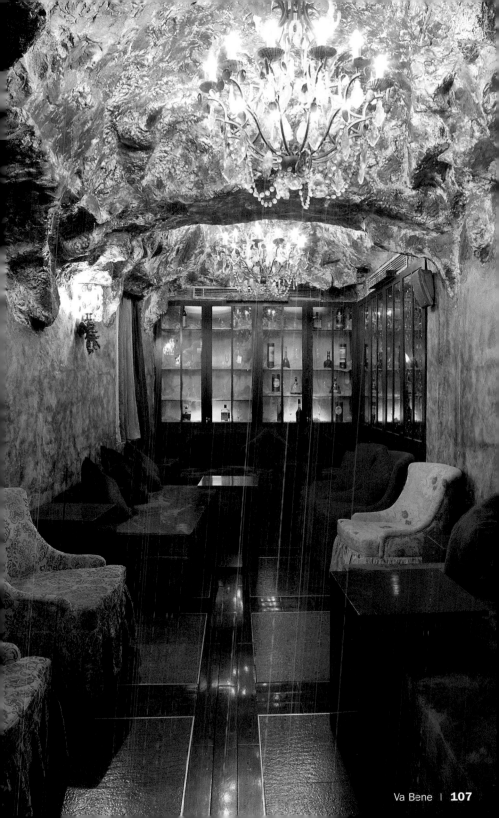

Whampoa Club

Design: Alan Chan | Chef: Jereme Leung

3 Zhong Shan Dong Yi Lu, No. 3 The Bund, 5th Floor | 200002 Shanghai
Phone: +86 21 6321 3737
www.threeonthebund.com
Subway: He Nan Zhong Lu
Opening hours: Every day 11:30 am to 2:30 pm, and 5:30 pm to 10 pm
Average price: € 47
Cuisine: Innovative Shanghainese
Special features: Antique furniture

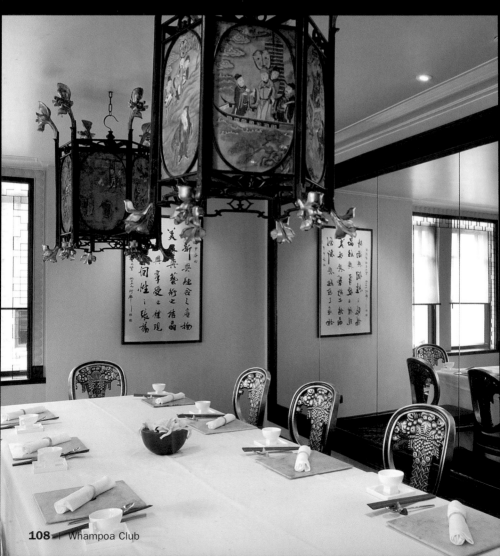

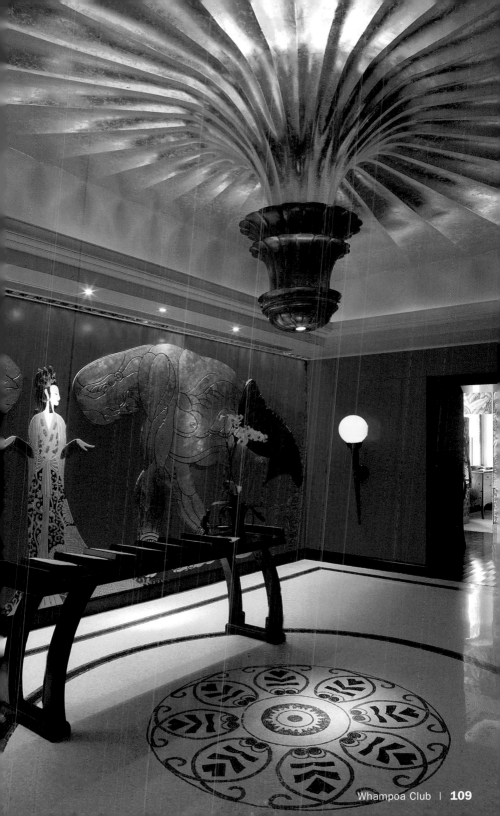

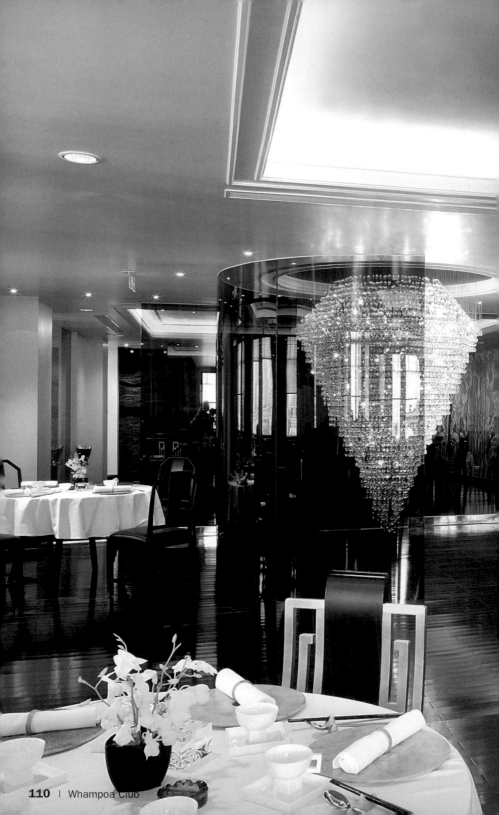

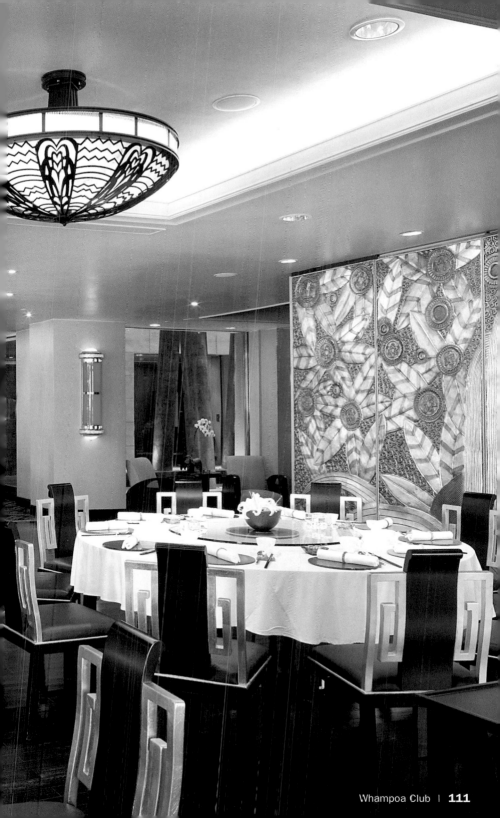

Marinated Chicken

Mariniertes Hähnchen

Poulet mariné

Pollo marinado

Pollo marinato

1 chicken (c. 3lb)
10 onion shoots
2 ginger roots
1 seed star anise
1 bay leaf
300 ml white rice wine
2 oz salt
1/2 oz sugar
Salt

For the chicken sauce: bring one liter of water to the boil and add five onion shoots, one ginger root, the sugar, the anise seed, the bay leaf and salt to taste. Simmer gently for 3 minutes, allow to cool and add 200 ml of the wine. Reserve half the sauce to marinate the chicken an place the rest in the freezer.

In another saucepan bring 1.5 liters of water t the boil, add the remaining five onion shoots the other ginger root and 100 ml of wine Reduce the heat, add the chicken and simme for 20 minutes. Once the chicken is cooked allow it to cool in iced water. Then bone the bir and leave to marinate in the fridge for 24 hours To serve: dice the chicken and place in cups pre viously cooled in the freezer. Sprinkle with th frozen sauce by scraping it with a spoon. Serv very cold.

1,5 kg Hähnchenfleisch
10 Zwiebelstängel
2 Ingwerwurzeln
1 Sternanissamen
1 Lorbeerblatt
300 ml weißen Reiswein
50 g Salz
15 g Zucker
Salz

Für die Sauce in einem Topf einen Liter Wasser zum Kochen bringen, die fünf Zwiebelstängel, die Ingwerwurzel, den Zucker, den Sternanissamen, ein Lorbeerblatt und Salz hinzugeben. Drei Minuten bei niedriger Hitze kochen lassen, abkühlen lassen und 200 ml Wein hinzugeben. Die Hälfte der Sauce beiseite nehmen, um da Hähnchen zu marinieren und die andere Hälft im Gefrierfach aufbewahren.

In einem anderen Topf 1,5 l Wasser zum Kocher bringen, fünf Zwiebelstängel, eine Ingwerwurze und 100 ml Wein hinzugeben. Die Hitze verrin gern, das Hähnchen in den Topf legen und au kleiner Flamme zwanzig Minuten kochen. Nac dem Kochen das Hähnchen in eiskaltem Wasse abkühlen, ausbeinen und im Kühlschrank 2∠ Stunden in der vorher zubereiteten Sauce mari nieren.

Anrichten: Das in Stücke geschnittene Hähnchen in einer eisgekühlten Tasse anrichten und mi der gefrorenen Sauce bepulvern, indem man si mit einen Löffel abkratzt. Sehr kalt servieren.

,5 kg de poulet
0 tiges d'oignon
racines de gingembre
graine d'anis étoilé
feuille de laurier
00 ml de vin blanc de riz
0 g de sel
5 g de sucre
el

our la sauce du poulet : amener un litre d'eau
ébullition dans une casserole. Ajouter cinq ti-
es d'oignon, la racine de gingembre, 15 g de
ucre, la graine d'anis étoilé, une feuille de lau-
er et du sel. Faire bouillir à feu doux 3 minu-
es puis laisser refroidir et ajouter 200 ml de vin.

Réserver la moitié de la sauce pour faire mari-
ner le poulet et conserver l'autre moitié au
congélateur.
Dans une autre casserole, amener 1,5 l d'eau à
ébullition, ajouter cinq tiges d'oignon, une raci-
ne de gingembre et 100 ml de vin. Réduire le
feu, ajouter le poulet et laisser cuire à feu doux
durant 20 minutes. Une fois la cuisson termi-
née, laisser refroidir le poulet dans de l'eau ge-
lée. Le désosser ensuite et le faire mariner au
réfrigérateur 24 heures avec la sauce préparée
précédemment.
Présentation : dans une tasse, préalablement
refroidie au congélateur, disposer le poulet dé-
coupé et le saupoudrer de la sauce congelée en
la râpant avec une cuillère. Servir bien froid.

,5 kg de pollo
0 tallos de cebollas
raíces de jengibre
semilla de anís estrellado
hoja de laurel
00 ml de vino blanco de arroz
0 g de sal
5 g de azúcar
al

Para la salsa del pollo, en una cazuela, llevar
a ebullición un litro de agua, añadir cinco tallos
de cebolla. la raíz de jengibre, 15 g de azúcar,
una semilla de anís estrellado, una hoja de lau-
rel y sal. Hervir a fuego lento durante 3 minutos;

dejar enfriar y añadir 200 ml de vino. Reservar
la mitad de la salsa para marinar el pollo y guar-
dar la otra mitad en el congelador.
En otra cazuela, llevar a ebullición 1,5 l de agua,
añadir cinco tallos de cebolla, una raíz de jengi-
bre y 100 ml de vino. Bajar el fuego, añadir el
pollo y cocer a fuego lento durante 20 minutos.
Una vez terminada la cocción, enfriar el pollo en
agua helada; luego deshuesarlo y marinarlo en
el frigorífico durante 24 horas con la salsa pre-
parada anteriormente.
Emplatado: en una taza que se habrá previa-
mente enfriado en el congelador, colocar el pollo
troceado y espolvorear con la salsa congelada
raspándola con una cuchara. Servir bien frío.

1,5 kg di pollo
10 steli di cipolla
2 radici di zenzero
1 seme di anice stellato
1 foglia di alloro
300 ml di vino bianco di riso
50 g di sale
15 g di zucchero
Sale

Per la salsa del pollo, in un tegame portare ad
ebollizione un litro d'acqua, aggiungere cinque
steli di cipolla, la radice di zenzero, 15 g di zuc-
chero, un seme di anice stellato, una foglia d'al-
loro e sale. Cuocere a fuoco lento per 3 minuti;
lasciare raffreddare e aggiungere 200 ml di vi-

no. Mettere da parte metà della salsa per mari-
nare il pollo e conservare l'altra metà nel freezer.
In un altro tegame, portare ad ebollizione 1,5 l
di acqua, aggiungere cinque steli di cipolla, un
radice di zenzero e 100 ml di vino. Abbassare la
fiamma, aggiungere il pollo e far cuocere a fuo-
co lento per 20 minuti. Una volta terminata la
cottura, far raffreddare il pollo in acqua ghiac-
ciata, dopodiché disossarlo, marinarlo con la
salsa preparata in precedenza e lasciarlo in fri-
go per 24 ore.
Presentazione: in una tazza fatta raffreddare pre-
cedentemente nel freezer, collocare il pollo a
pezzi e cospargerlo con la salsa congelata ra-
schiandola con un cucchiaio. Servire ben freddo.

Yè Shanghai

Design: Tony Chi & Associates | Chef: Zuoqun Zhang

Unit 1, House 6, Lane 181, Taicang Lu, North Block, Xintiandi Plaza | 200021 Shangh
Phone: +86 21 6311 2323
www.xintiandi.com
Subway: Huang Pi Nan Lu
Opening hours: 11:00 am to 2:30 pm, and 5:30 pm to 10:30 pm
Average price: € 33
Cuisine: Jiangsu, Zhejiang & Shanghai Gourmet

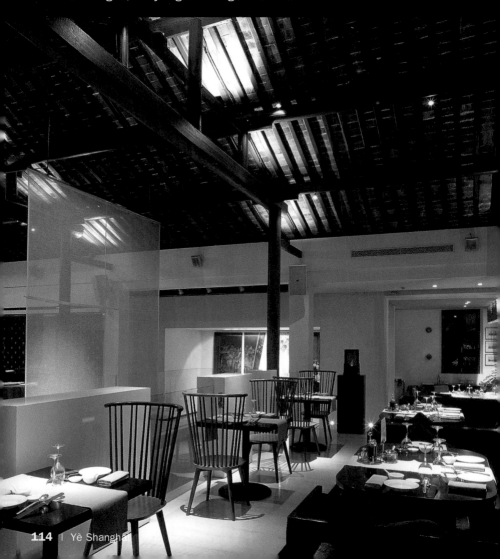

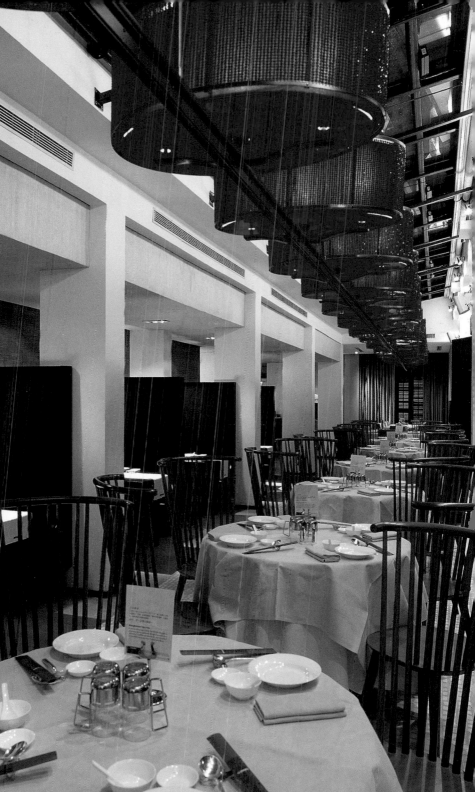

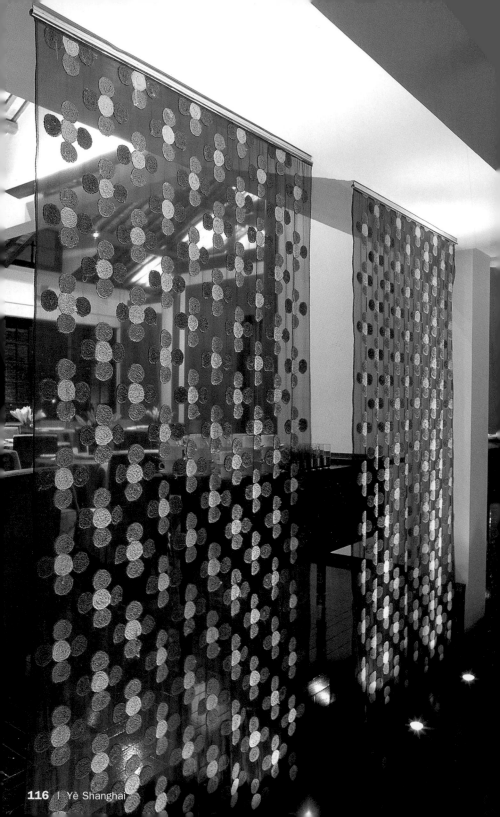

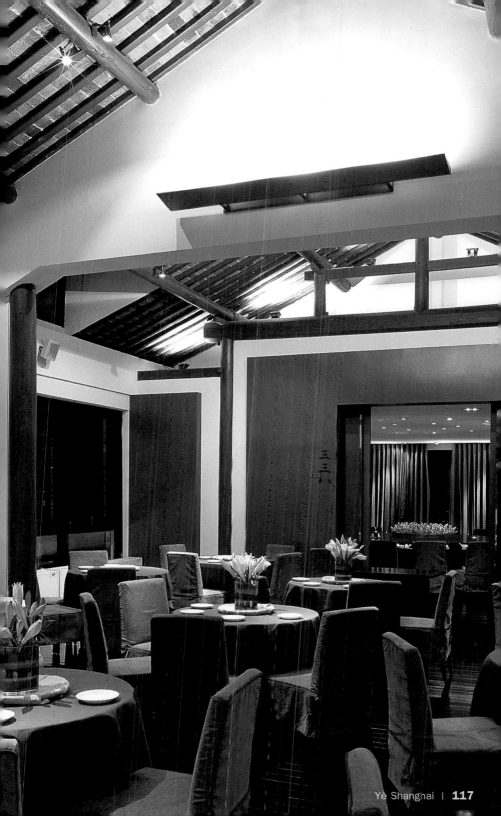

Hot Prawn-Meat Balls

Pikante Krabbenfleischklöße

Boulettes piquantes

Albóndigas picantes

Polpette piccanti

1 lb prawn-meat balls
1/3 oz finely chopped onion
1 red chili pepper
1/6 oz powdered chicken stock
10 ml hot chili oil
20 ml white wine
25 ml chili sauce
1/6 oz chopped ginger
1 pinch pepper
1 3/4 oz starch
1 egg white
20 ml olive oil
1/3 oz chives
Salt

Sprinkle the meat balls with salt and then remove the excess salt. Beat the egg white, add salt to taste and blend with the wine, chili oil and starch. Roll the meat balls in this mixture and fry them. Reserve. In another frying pan heat the oil and fry the onion, the chopped chili pepper, the chili sauce and the ginger. Dissolve the powdered chicken stock in water and add to the mixture together with the meat balls. Fry for 5 minutes.
To serve: arrange the meat balls on a flat plate, sprinkle with pepper and decorate with the finely chopped chives.

500 g Klößchen aus Krabbenfleisch
10 g gehackte Zwiebel
1 rote Chilischote
5 g Hühnerbrühe in Pulverform
10 ml pikantes Chiliöl
20 ml Weißwein
25 ml Chilisauce
5 g gehackter Ingwer
1 Prise Pfeffer
50 g Stärke
1 Eiweiß
20 ml Olivenöl
10 g Schnittlauch
Salz

Die Klößchen mit Salz bestreuen und anschließend das überschüssige Salz entfernen. Das Eiweiß schlagen, salzen und mit dem Weißwein, dem Chiliöl und der Stärke vermischen. Die Klößchen mit dieser Masse panieren und frittieren. Zur Seite stellen. In einer anderen Pfanne das Öl erhitzen und die Zwiebel, die gehackte Chilischote, die Chilisauce und den Ingwer anbraten. Die Hühnerbrühe in Wasser auflösen und mit den Klößchen in die Sauce aus angebratenen Zwiebeln geben. 5 Minuten lang braten.
Anrichten: Die Klößchen auf einen flachen Teller legen, pfeffern und mit dem fein gehacktem Schnittlauch dekorieren.

500 g de boulettes de crevettes
10 g d'oignon haché
1 chili rouge
5 g de bouillon de poulet en poudre
10 ml d'huile de chili piquante
20 ml de vin blanc
25 ml de sauce chili
5 g de gingembre haché
1 prise de poivre moulu
50 g de fécule
1 blanc d'œuf
20 ml d'huile d'olive
10 g de ciboule
Sel

Saupoudrer les boulettes de sel et éliminer ensuite l'excès. Battre le blanc, saler et amalgamer avec le vin blanc, l'huile de chili et la fécule. Paner les boulettes avec la préparation et les faire frire. Réserver. Dans une autre poêle, chauffer l'huile et faire sauter l'oignon, le chili haché, la sauce chili et le gingembre. Dissoudre le bouillon de poulet dans de l'eau et y ajouter le sofrito avec les boulettes. Faire frire 5 minutes.
Présentation : disposer les boulettes dans un plat, saupoudrer de poivre et décorer de ciboule hachée.

500 g de albóndigas de gamba
10 g de cebolla picada
1 pimiento chile rojo
5 g de caldo de pollo en polvo
10 ml de aceite de chile picante
20 ml de vino blanco
25 ml de salsa de chile
5 g de jengibre picado
1 pizca de pimienta en polvo
50 g de fécula
1 clara de huevo
20 ml de aceite de oliva
10 g de cebollino
Sal

Espolvorear las albóndigas con sal y eliminar luego el exceso de sal. Batir la clara, salar y amalgamar con el vino blanco, el aceite de chile y la fécula. Rebozar la albóndigas en el preparado y freírlas. Reservar. En otra sartén, calentar el aceite y sofreír la cebolla, el pimiento chile picado, la salsa de chile y el jengibre. Disolver en agua el caldo de pollo en polvo y añadirlo al sofrito con las albóndigas. Freír durante 5 minutos.
Emplatado: Disponer las albóndigas en un plato llano, espolvorear con pimienta y adornar con cebollino picado.

500 g di polpette di gambero
10 g di cipolla tritata
1 peperone piccante rosso
5 g di brodo di pollo in polvere
10 ml di olio al peperoncino piccante
20 ml di vino bianco
25 ml di salsa di peperoncino piccante
5 g di zenzero tritato
1 pizzico di pepe in polvere
50 g di fecola
1 albume d'uovo
20 ml di olio d'oliva
10 g di cipollino
sale

Spolverizzare le polpette di sale dopodiché eliminare il sale in eccesso. Sbattere l'albume, salare e amalgamare con il vino bianco, l'olio al peperoncino piccante e la fecola. Bagnare le polpette nel preparato, friggerle e metterle da parte. In un'altra padella, riscaldare l'olio e soffriggere la cipolla, il peperone piccante tritato, la salsa di peperoncino e lo zenzero. In un po' d'acqua sciogliere il brodo di pollo in polvere e aggiungerlo al soffritto assieme alle polpette. Friggere per 5 minuti.
Presentazione: disporre le polpette su un piatto piano, spolverizzare con pepe e adornare con un po' di cipollino tritato.

Zen

Design: Houming Fu I Chef: Weixin Mai

House 2, Lane 123, Xingye Lu, South Block, Xintiandi Plaza I 200021 Shanghai
Phone: +86 21 6385 6385
www.xintiandi.com
Subway: Huang Pi Nan Lu
Opening hours: Every day 11:30 am to 11:30 pm
Average price: € 23
Cuisine: Cantonese

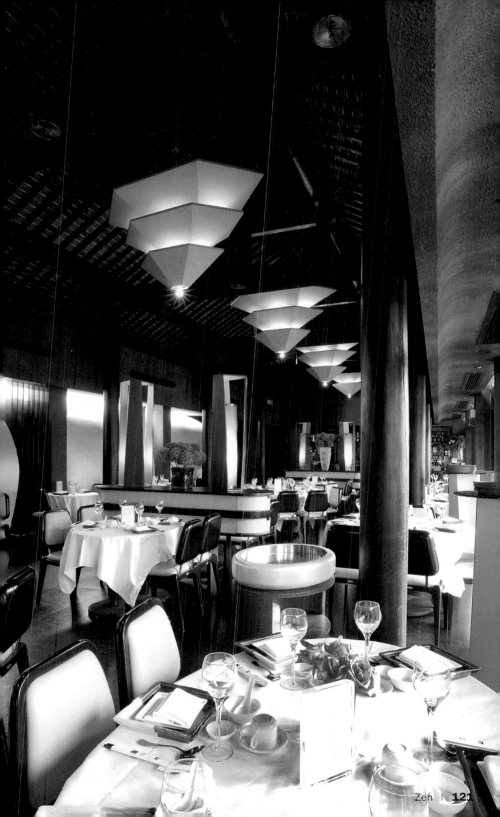

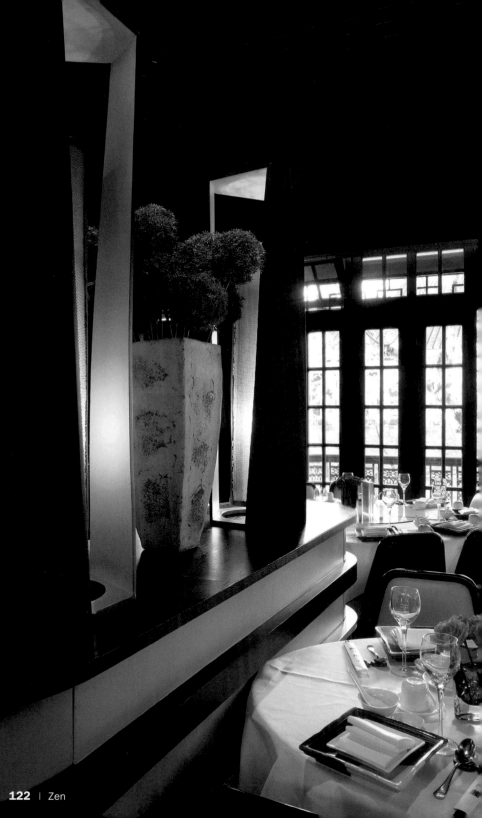

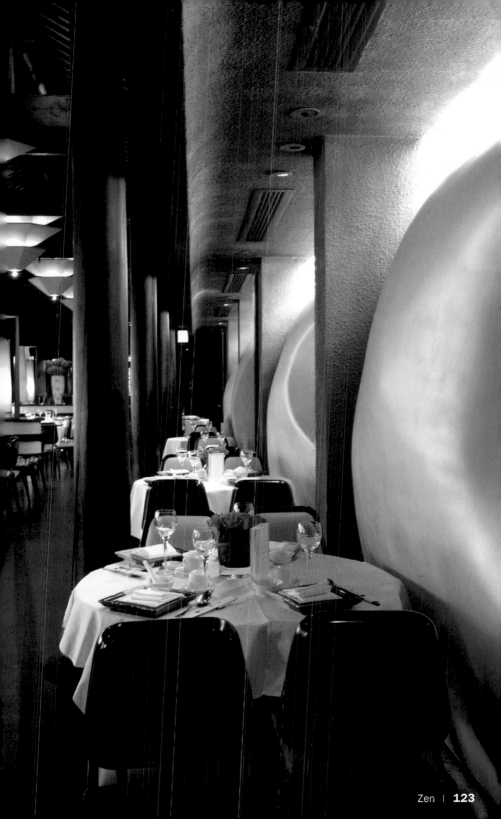

Stuffed

Chicken Wings

Gefüllte Hähnchenflügel

Ailes de poulet farcies

Alitas rellenas

Alette ripiene

10 chicken wings
3 1/2 oz scallop meat
1 3/4 oz shelled king prawns
1 3/4 oz mushrooms
3 1/2 oz rice
1 clove garlic
250 ml olive oil

Wash and cut up the mushrooms and sauté in the oil and garlic for 5 minutes. Add the rice and cook for a further 10 minutes, adding water from time to time to prevent the rice from burning. Bone the wings, wash and dry them and stuff them with the rice, the scallop meat and the chopped king prawns. Heat plenty of oil in a pan and fry the wings until golden.
Serve lukewarm on a flat plate.

10 Hähnchenflügel
100 g Fleisch von Kammmuscheln
50 g saubere Garnelen
50 g Pilze
100 g Reis
1 Knoblauchzehe
250 ml Olivenöl

Die Pilze waschen, trocknen und in einer Pfanne mit dem Öl und Knoblauch 5 Minuten anbraten. Den Reis hinzugeben und 10 Minuten kochen lassen, dabei immer wieder Wasser hinzugeben, damit der Reis nicht anbrennt. Die Hähnchenflügel ausbeinen, waschen, trocknen und mit dem Reis, dem Fleisch den Kammmuscheln und dem gehackten Garnelenfleisch füllen. In einer Pfanne reichlich Öl erhitzen und die Flügel darin goldbraun frittieren.
Anrichten: Auf einem flachen Teller nicht sehr heiß servieren.

0 ailes de poulet
00 g de pulpe de coquille St Jacques
0 g de langoustines nettoyées
0 g de champignons
00 g de riz
 pointe d'ail
50 ml d'huile d'olive

Laver et détailler les champignons. Les faire sauter à la poêle avec de l'huile et l'ail durant 5 minutes. Ajouter le riz et laisser cuire 10 minutes de plus, en n'oubliant pas d'ajouter de l'eau de temps en temps pour que le riz ne brûle pas. Désosser les ailes de poulet. Les laver, les sécher et les farcir avec le riz, la pulpe de coquille St Jacques et la chair hachée des langoustines. À la poêle, chauffer de l'huile en abondance et frire les ailes pour qu'elles soient dorées. Présentation : servir tiède dans un plat.

0 Alitas de pollo
100 g de pulpa de vieira
50 g de langostinos limpios
50 g de setas
100 g de arroz
1 diente de ajo
250 ml de aceite de oliva.

Lavar y trocear las setas y sofreírlas en una sartén con aceite y ajo durante 5 minutos. Añadir el arroz y cocer durante 10 minutos más, teniendo cuidado de añadir agua cada tanto para que el arroz no se queme. Deshuesar las alitas de pollo, lavarlas, secarlas y rellenarlas con el arroz, la pulpa de vieira y la carne picada de los langostinos. En una sartén, calentar abundante aceite y freír las alitas hasta que se doren. Emplatado: Servir templadas en plato llano

10 Alette di pollo
100 g di polpa di vieira
50 g di gamberetti puliti
50 g di funghi
100 g di riso
1 spicchio d'aglio
250 ml di olio d'oliva

Lavare e tagliare a pezzetti i funghi, friggerli in una padella con olio ed aglio per 5 minuti. Aggiungere il riso e cuocere per ancora 10 minuti; ogni tanto versare un po' d'acqua per evitare che l riso si attacchi e si bruci. Disossare le alette di pollo, lavarle, asciugarle e farcirle con il riso, la polpa di vieira e la carne tritata dei gamberetti. In una padella, riscaldare dell'olio abbondante e friggere le alette fino a farle dorare. Presentazione: servire le alette tiepide in un piatto piano.

Zenter Stage

Design: Houming Fu

Shopping Building, 5th floor, Lane 123, Xingye Lu, South Block, Xintiandi |
200021 Shanghai
Phone: +86 21 6384 6384
Subway: Huang Pi Nan Lu
Opening hours: Every day 11 am to 1:30 pm and 5:30 pm to 9:30 pm
Average price: Lunch € 5, Dinner € 10
Cuisine: Mixed Continental

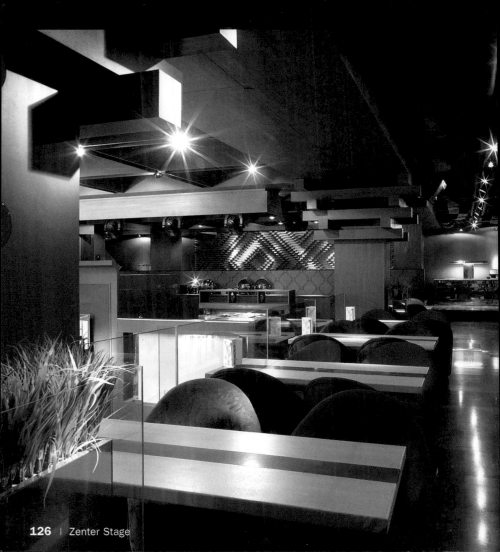

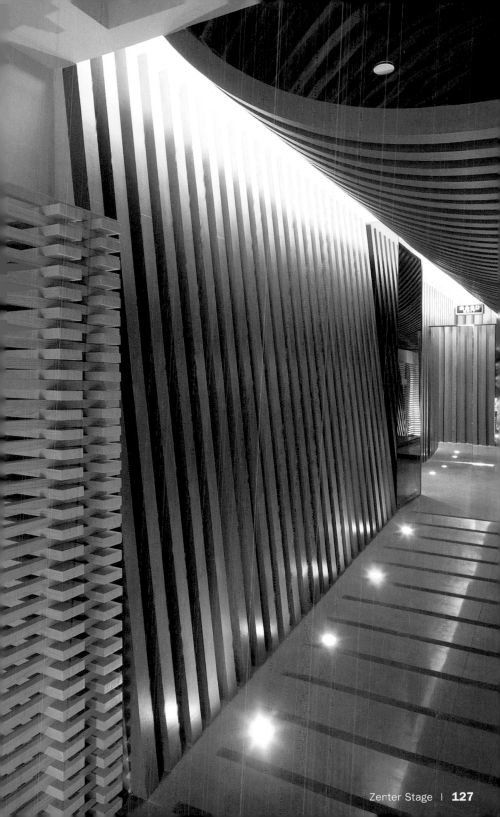

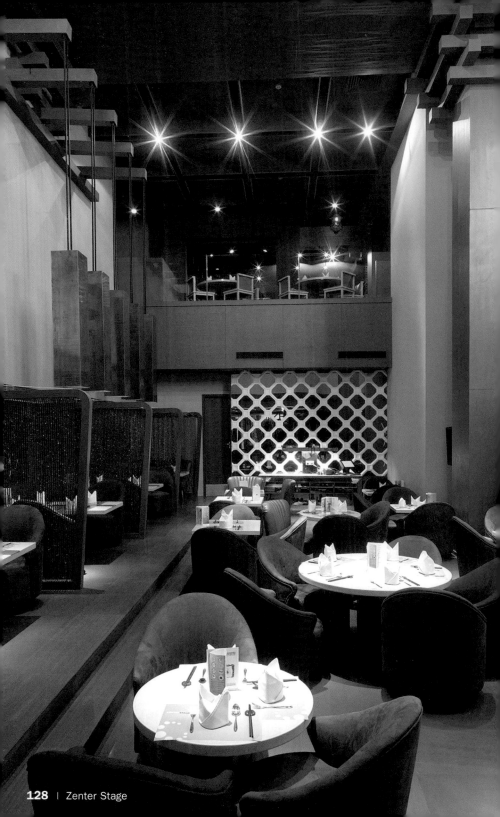

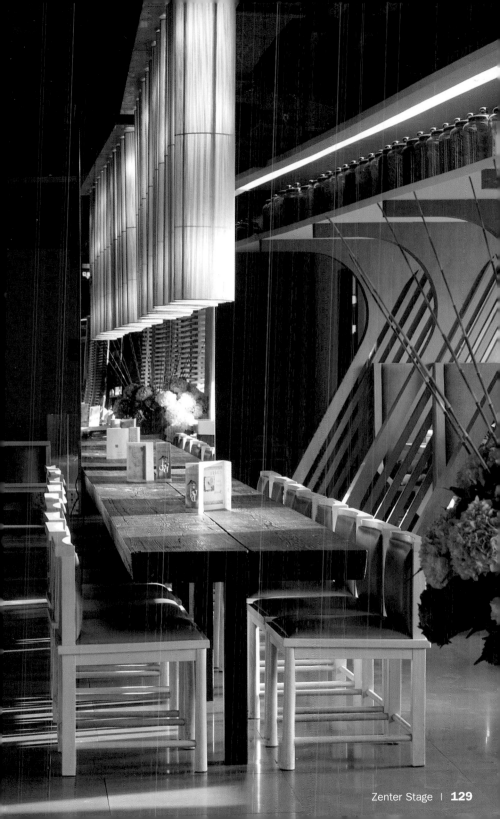

Zhen Guan

68 Taicang Lu I 200021 Shanghai
Phone: +86 21 5382 5581
Subway: Huang Pi Nan Lu
Opening hours: 11 am to 2:30 am
Average price: € 9
Cuisine: Innovative Chinese
Special features: Contemporary style mixed with artworks

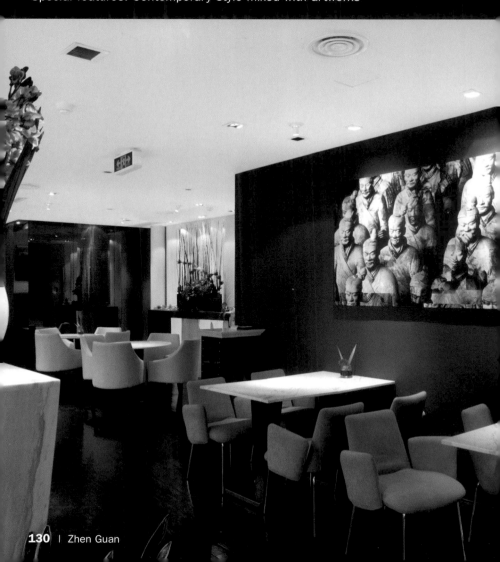

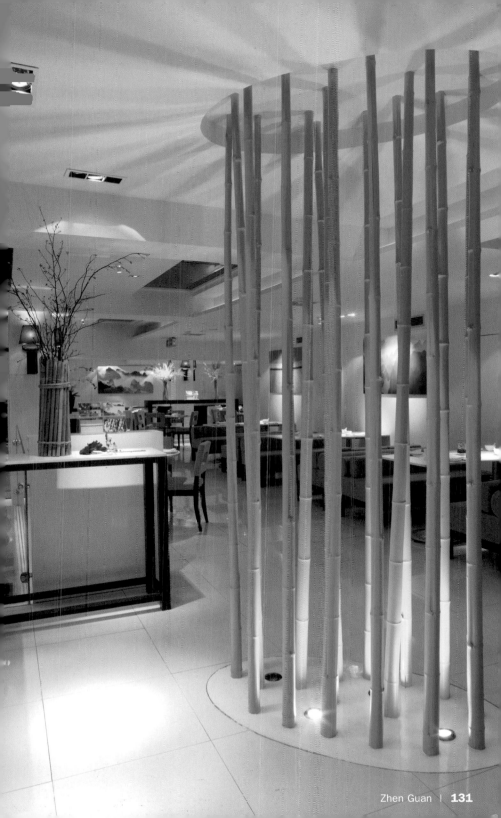

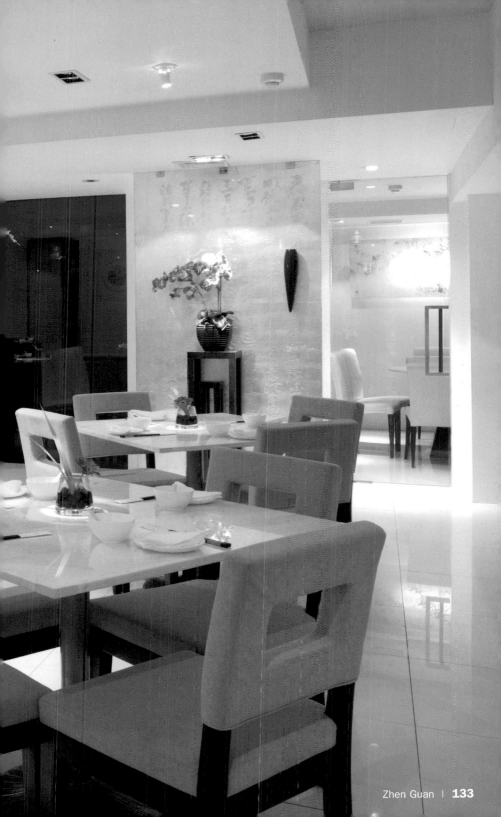

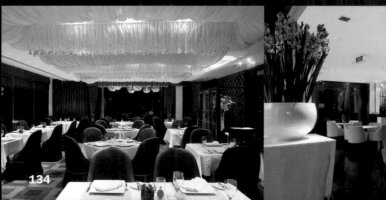

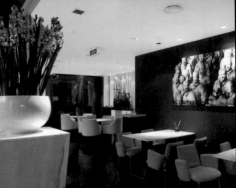

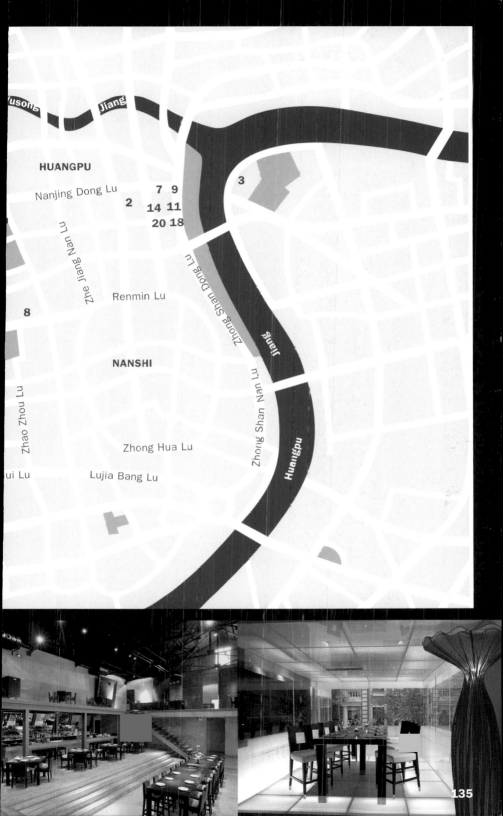

HUANGPU

Nanjing Dong Lu 7 9

2

14 11

20 18

3

Zhe Jiang Nan Lu

Renmin Lu

Zhong Shan Dong Lu

Jiang

8

NANSHI

Zhao Zhou Lu

Zhong Shan Nan Lu

Zhong Hua Lu

Lujia Bang Lu

ui Lu

Huangpu

Yusong Jiang

Cool Restaurants

Size: 14 x 21.5 cm / 5 1/2 x 8 in.
136 pp
Flexicover
c. 130 color photographs
Text in English, German, French, Spanish and (*) Italian

Other titles in the same series:

Amsterdam (*)
ISBN 3-8238-4588-8

Milan (*)
ISBN 3-8238-4587-X

Barcelona (*)
ISBN 3-8238-4586-1

Munich (*)
ISBN 3-8327-9019-5

Berlin (*)
ISBN 3-8238-4585-3

New York
ISBN 3-8238-4571-3

Brussels (*)
ISBN 3-8327-9065-9

Paris
ISBN 3-8238-4570-5

Chicago (*)
IISBN 3-8327-9018-7

Prague (*)
ISBN 3-8327-9068-3

Côte d'Azur (*)
ISBN 3-8327-9040-3

Rome (*)
ISBN 3-8327-9028-4

Hamburg (*)
ISBN 3-8327-9040-3

San Francisco (*)
ISBN 3-8327-9067-5

London
ISBN 3-8238-4568-3

Sydney (*)
ISBN 3-8327-9027-6

Los Angeles (*)
ISBN 3-8238-4589-6

Tokyo (*)
ISBN 3-8238-4590-X

Madrid (*)
ISBN 3-8327-9029-2

Vienna (*)
ISBN 3-8327-9020-9

Miami (*)
ISBN 3-8327-9066-7

Zurich (*)
ISBN 3-8327-9069-1

To be published in the same series:

Cape Town Moscow
Geneva Stockholm
Hong Kong